M000087691

POSTCARD HISTORY SERIES

Petersburg

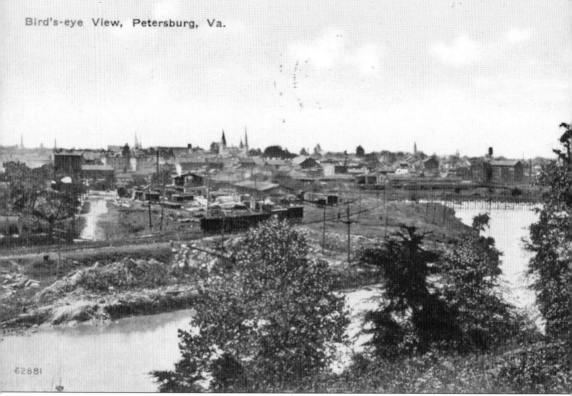

Bird's-eye View, Petersburg, Va.

62881

VIEW OF PETERSBURG WITH POCAHONTAS ISLAND. Established as a town in 1752, Pocahontas was incorporated into Petersburg in 1784. By 1800, many of Petersburg's 310 free blacks were residing on this land that was originally on the north bank of the Appomattox. After the Civil War, the land became home to a number of freed slaves. By the time this image was produced in 1912, Pocahontas had become an island. In 1909, a diversion channel was constructed to divert the flow of the Appomattox River in an effort to prevent flooding in Petersburg, resulting in the formation of Pocahontas Island.

ON THE FRONT COVER: THE COURTHOUSE AND SURROUNDING AREA. Since its completion in 1839, the courthouse tower has been a prominent feature of Petersburg's skyline. The first U.S. flag to be flown in Petersburg after the Civil War siege had ended was hung from the tower on April 3, 1865. This view dating from about 1920 shows a residential neighborhood behind the building with Centre Hill Mansion and the Centre Hill apartment building in the background.

ON THE BACK COVER: SYCAMORE STREET FROM WASHINGTON STREET. This view of Sycamore Street looking north was printed around 1920. Businesses on this block during that era include the Model Steam Laundry, whose sign is partially visible on the right, J. T. Morriss and Son funeral home, and the Plaza Restaurant.

Petersburg

Laura E. Willoughby

ARCADIA
PUBLISHING

Copyright © 2006 by Laura E. Willoughby
ISBN 0-7385-4285-7

Published by Arcadia Publishing
Charleston SC, Chicago IL, Portsmouth NH, San Francisco CA

Printed in the United States of America

Library of Congress Catalog Card Number: 2006923524

For all general information contact Arcadia Publishing at:
Telephone 843-853-2070
Fax 843-853-0044
E-mail sales@arcadiapublishing.com
For customer service and orders:
Toll-Free 1-888-313-2665

Visit us on the Internet at www.arcadiapublishing.com

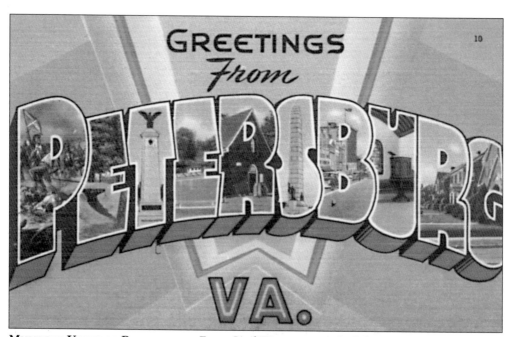

MULTIPLE VIEWS OF PETERSBURG. From Civil War scenes on the left to a 20th-century suburb on the right, this postcard captures a spectrum of images that represented Petersburg's past and present around 1940.

CONTENTS

ACKNOWLEDGMENTS

The majority of the postcards in this volume are in the Petersburg Museums' permanent archives. The archives and this publication are a result of the efforts of generous individuals who have donated their collections of postcards and archival material to the museums. Thanks to these donors, this facet of Petersburg's history can be shared with others and preserved for future generations.

Permission was granted by Russell W. Davis to reproduce several postcards from his vast collection for this publication. Chris Calkins, chief of interpretation for the Petersburg National Battlefield, also shared postcards from his personal collection and provided research assistance. Additional individuals who contributed information on their various fields of expertise include Lucious Edwards, university archivist, Virginia State University; Victoria Hauser, preservation planner for the City of Petersburg; and Dulaney Ward, historian and special projects consultant for the city. Doug Harris, museum collections assistant, provided diligent research and fact-checking services. Kathryn Korfonta, my editor from Arcadia Publishing, also deserves credit for her expert guidance and helpful suggestions.

I would like to thank all the Petersburg Museums staff for sharing tidbits of information on 20th-century life in Petersburg and for their efforts to keep the museums a fun and lively place to work! Last but not least, I would like to thank my family and friends for their support and enthusiastic interest in this project.

INTRODUCTION

In the early 20th century, postcards provided an inexpensive and convenient method for keeping in touch with loved ones. The passage of the 1898 Private Mailing Card Act by the federal government created a viable industry for private publishing companies by giving them the right to print and sell cards for mailing. Images of commonplace and exotic locales from all over the world were printed on the face of the cards. Collecting postcards also became a hobby for many during this era. Postcard production reached its height between the years 1907 and 1915, when millions of cards were manufactured to satisfy the demand for cards to both collect and mail.

While there was a worldwide decline in the postcard industry after 1915 due to World War I, the increasing availability of the telephone, and the emergence of the cinema as a more sophisticated form of visual entertainment, the development of new lithographic and photographic processes kept many American postcard publishers in business through the mid-20th century. Roadside attractions that sprang up along America's newly built highways provided new vehicles for postcard distribution. Today postcards from the early to mid-20th century provide an extraordinary array of visual documentation on many facets of everyday life from that era.

At the height of the postcard's popularity, Petersburg was experiencing both economic and physical growth. Businesses and industries were establishing themselves in a city that a generation earlier was facing a dire shortage of goods and services as a result of the military siege during the Civil War. In the first decades of the 20th century, railroads, boats, streetcars, and automobiles were efficiently bringing people to and from the city and were providing reliable means of traveling around the growing municipality. Schools were being established, churches representing diverse denominations continued to thrive, and new neighborhoods were being built. Many of these trends can be documented on the postcard scenes of Petersburg that were published during this era.

Postcards were also being produced to commemorate Petersburg's long and illustrious history. The legacy of the Civil War and of Petersburg's antebellum history is preserved in buildings, monuments, memorials, and cemeteries in the city. Many of these sites were documented on postcards.

The city of Petersburg grew out of a fort that was established on the banks of the Appomattox River around 1645. By the early 18th century, the area was prospering with the influx of new settlers and the cultivation of tobacco. Petersburg was the site of a 1781 Revolutionary War battle.

During the 19th century, Petersburg grew into a bustling commercial, agricultural, and cultural center. By the beginning of the Civil War, Petersburg was the second-largest city in Virginia and had the largest population of free African Americans in the state. The 1860 U.S. census recorded 18,266 residents in the city. However, the onslaught of the Civil War and the

1864–1865 military siege of Petersburg brought physical damage to the city and left residents desperate for food, clothing, and other basic necessities.

The five railroads that crossed through Petersburg, the city's location on the Appomattox River, and its proximity to the Confederate capital of Richmond made the city a prime military objective for the federal army. On June 9, 1864, members of the local Petersburg militia fought off the first federal attack on Petersburg in what is now known as the Battle of Old Men and Young Boys. Fifteen Petersburg men died in this battle. In the months that followed, much effort was spent by both federal and Confederate sides digging and strengthening lines around Petersburg, especially after the Battle of the Crater. This conflict resulted after federal troops dug a mine shaft to reach a Confederate fort. The tunnel was loaded with explosives and the fuse was lit in the early morning of July 30, 1864. On the morning of April 2, 1865, General Grant's troops waged a massive onslaught against the Confederate trenches and the main defenses crumbled; the Siege of Petersburg had ended.

For the next several decades, monuments and memorials to the soldiers on both sides of the conflict were dedicated in and around Petersburg. The Ladies Memorial Association, an organization of local women, worked tirelessly to raise funds from former Confederate states to have 15 memorial windows designed and executed by the studio of Louis Comfort Tiffany installed in the Old Blandford Church. The most documented dedication ceremony took place on May 19, 1909, when Pres. William Howard Taft visited Petersburg to unveil a monument dedicated to a division of Pennsylvania soldiers.

By 1912, Petersburg had a population of nearly 25,000. That same year, the Petersburg edition of the *International Magazine of Industry and the Daily Progress* reported that, "There is no section of the United States richer in its horticultural, agricultural, industrial and commercial wealth than the territory lying between the James River and North Carolina border known as Southside Virginia and of which Petersburg is the Metropolis." While it may be difficult to verify the economic accuracy of this observation, postcards from this era depicting businesses, educational facilities, industries, and abundant natural resources give credence to the published statement. Almost every facet of life in this historic and progressive community during the first half of the 20th century was captured in a postcard print. Today we are the lucky beneficiaries of this pictorial art that generations before was merely considered an efficient and quick form of communication.

One

THE CIVIL WAR

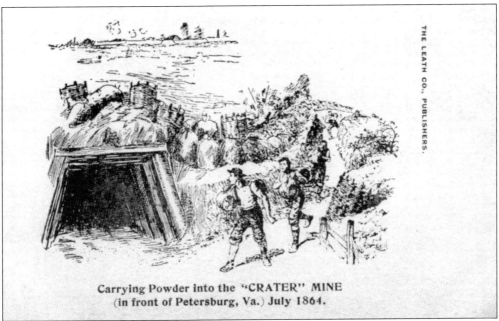

Carrying Powder into the "CRATER" MINE
(in front of Petersburg, Va.) July 1864.

CARRYING POWDER INTO THE CRATER MINE. In June 1864, a plan was hatched by members of the federal 9th Corps to blow up a Confederate fort located just over 100 yards from their trench. On June 25, 1864, work was begun by the 48th Pennsylvania Volunteers on the construction of an underground tunnel that would extend from their position to the Confederate line. The men in the 48th Pennsylvania, who were mostly coal miners, dug the 500-plus-foot tunnel. On July 27, the daylong task of carrying four tons of powder into the tunnel was begun. This illustration depicts that scene, although the postcard itself was published between 1901 and 1907, 37 to 43 years after the explosion took place.

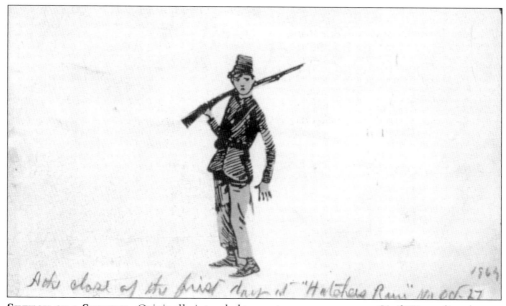

In the image, handwritten inscription reads: *A the close of the first day at "Hatchers Run" on Oct. 27* *1864*

SKETCH OF A SOLDIER. Originally intended to portray an anonymous Civil War enlisted man, this image has been personalized with the inscription underneath. The puzzling statement reads, "At the close of the first day at 'Hatcher's Run' Oct. 27, 1864." This postcard was printed after 1907. The above-mentioned conflict took place in Dinwiddie County, where troops fought over control of the Boydton Plank Road, a major route into Petersburg.

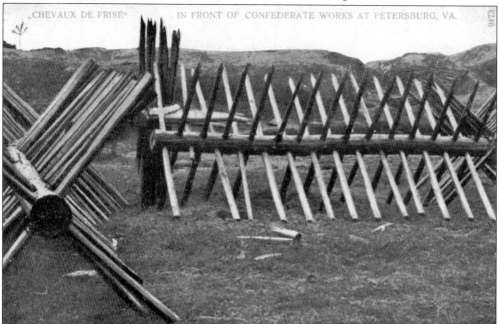

„CHEVAUX DE FRISE" IN FRONT OF CONFEDERATE WORKS AT PETERSBURG, VA.

CHEVAUX-DE-FRISE. Used for defense primarily by Confederate soldiers, lines of chevaux-de-frise were built in front of earthworks. Sharpened lances with points projecting outwards on all sides were supported by horizontal beams. This and the following three postcards were distributed by T. S. Beckwith and Company, a Petersburg stationery, book, and office supply store that was founded in 1865. The cards date from after 1907.

POWDER MAGAZINE. In 1862, Confederate engineer Charles Dimmock built a string of 55 defensive batteries in a 10-mile arc around Petersburg. The forts were linked together by earthworks. In June 1864, after several failed assaults, federal troops began digging their own series of entrenchments. Both sides would man their trenches day and night for the next nine months.

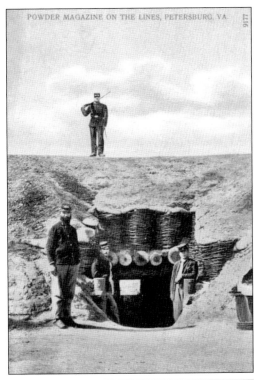

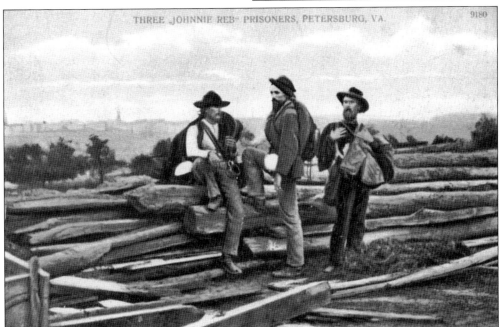

PRISONERS OF WAR. During the war, Petersburg never became a large prison center, although several buildings were used to temporarily hold prisoners of war, especially federal officers, before they were sent to permanent prisons. The scene shown here portrays an idyllic setting behind enemy lines. The prisoners appear to be well clothed with ample supplies. Postcards were an ideal medium for reprints of artwork produced during and after the war.

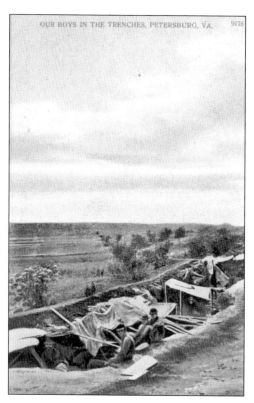

TRENCH LIFE. This scene shows daily life in the trenches under ideal conditions. Between skirmishes, life behind the fortifications was routine and uneventful. James H. Smith of the 81st New York wrote in his diary in 1864, "This is the 21st anniversary of my birthday. I think I never spent so dull a one in my life before. Nothing to distinguish it from the monotony of other days."

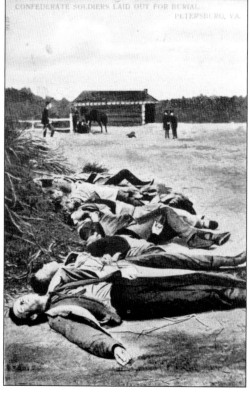

CONFEDERATE SOLDIERS LAID OUT FOR BURIAL. This is another example of Civil War artwork reprinted on postcards. This card and the preceding four postcards were printed in Germany between 1907 and 1915. Germany had the most advanced lithographic processes up until World War I. The demand for Civil War scenes appeared to be strong during this era.

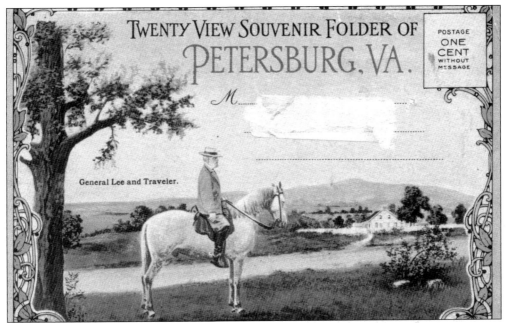

POSTCARD FOLDER COVER, GENERAL LEE. Some 55 years after the end of the Civil War, the publisher of this postcard collection chose to associate Petersburg with the Confederate general by placing an image of him on the cover. This scene is strikingly different than the images of prominent city sites found inside the packet. A reproduction of the Battle of the Crater painting, seen below, was printed on the back cover.

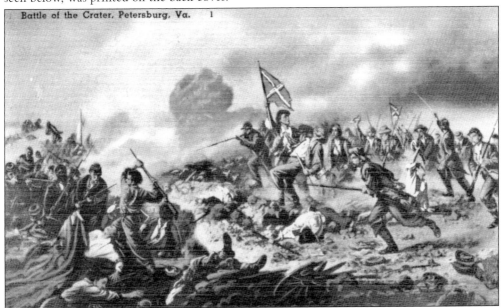

THE BATTLE OF THE CRATER PAINTING. This widely reproduced 1869 painting by John A. Elder depicts soldiers from Gen. William Mahone's brigade charging to fill the gap in the Confederate lines after the July 30, 1864, federal explosion of the mine. Elder, who was present at the battle, produced a small sketch that became the basis for his larger painting. Elder's painting hung in General Mahone's Petersburg residence.

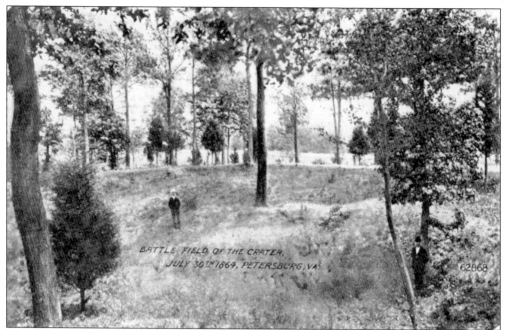

THE CRATER. The property where the Battle of the Crater took place was located on farmland belonging to William H. Griffith. Due to the large number of visitors to the site in the years after the war, Mr. Griffith built walkways to the mouth of the crater and constructed a refreshment stand and a building to house war relics. In 1871, a visitor to the site described seeing a vast hollow in the earth and human bones, shreds of uniforms, and pieces of cartridge pouches and bayonet scabbards still scattered on the ground. An admission fee of 25¢ was charged for access to the grounds. Mr. Griffith's son continued the operation of the site until his death in 1903. The property remained with his heirs until 1918. These postcards date from 1910 and 1911.

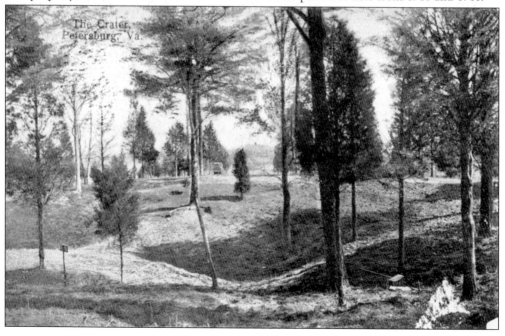

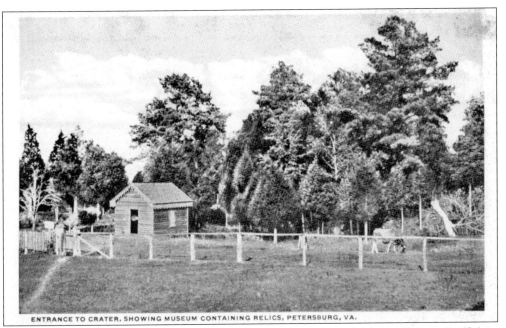

ENTRANCE TO CRATER, SHOWING MUSEUM CONTAINING RELICS, PETERSBURG, VA.

ENTRANCE TO THE CRATER. The small, framed relic house was built by William Griffith in 1866 for his collection of Civil War artifacts. The structure stood near the crater until the late 1920s. Mr. Griffith's son was especially instrumental in collecting artifacts for public display inside the house in the late 19th century.

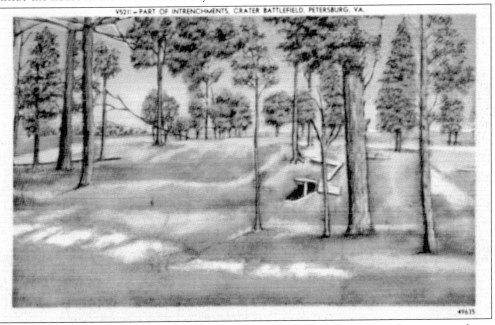

V521 – PART OF INTRENCHMENTS, CRATER BATTLEFIELD, PETERSBURG, VA.

49635

ENTRENCHMENTS, CRATER BATTLEFIELD. A re-excavation of the federal mine tunnel was started in 1926 by the Crater Battlefield Association. An entrance to the excavated portion of the tunnel was built but closed several years later when portions of the tunnel began to collapse. The National Park Service discovered and reconstructed the tunnel entrance in 1937. The entrance closed in 1946 when maintenance issues became a problem.

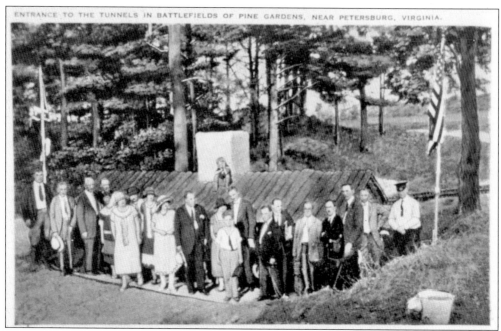

ENTRANCE TO TUNNELS IN PINE GARDENS. These tunnels, located in the vicinity of Fort Sedgwick and Fort Mahone, were discovered by a farmer plowing his field in 1909. The property eventually became part of a real-estate development called Pine Gardens owned by David A. Lyon Jr. On September 2, 1925, Mr. Lyon opened the tunnels to the public with a dedication ceremony attended by Virginia governor Elbert Lee Trinkle. The site remained open to visitors until 1943, when the structures were deemed unsafe for public access due to a lack of support for the roof. By 1959, the last of the remaining tunnels had been filled in.

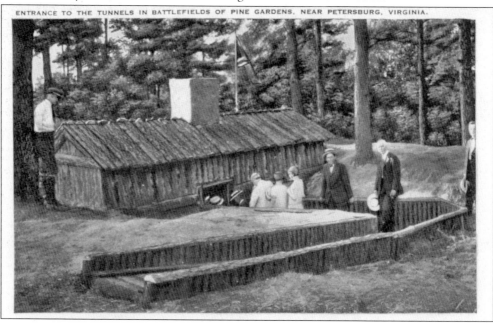

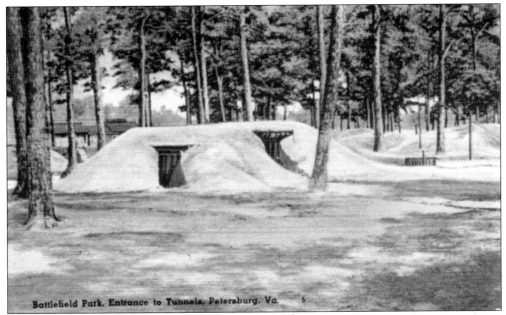

Battlefield Park, Entrance to Tunnels, Petersburg, Va.

FORT HELL. Fort Sedgwick was nicknamed Fort Hell by Confederate soldiers due to the constant barrage of artillery fire by federal troops stationed at the fort. These dug-outs were used as magazines or officers' quarters. Mr. Lyon opened the site as a tourist attraction in 1932 complete with a museum, library, and gift shop. The site operated for 34 years, until the property was sold in 1966.

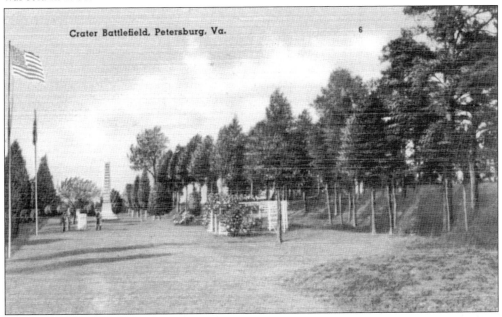

Crater Battlefield, Petersburg, Va.

CRATER BATTLEFIELD. On July 3, 1926, the Petersburg National Military Park was officially established by an act of Congress. However, the Crater Battlefield remained in private hands until it was acquired by the National Park Service in 1936. The sloping land on the right marks the edge of the crater. The Mahone monument in the background was erected by the United Daughters of the Confederacy in 1927.

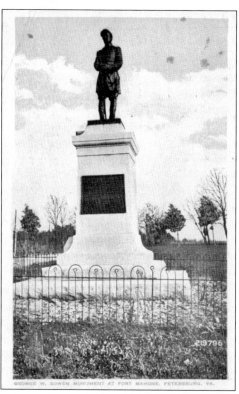

GEORGE W. GOWAN MONUMENT.
Dedicated on June 20, 1907, this statue was erected by survivors of the 48th Regiment of the Pennsylvania Volunteer Infantry and citizens of Schuylkill County, Pennsylvania, in memory of Col. George Gowan and other members of the 48th Regiment who were killed during an assault on Confederate defenses near Fort Mahone on April 2, 1865. The monument stands at the junction of U.S. 301 and U.S. 301A.

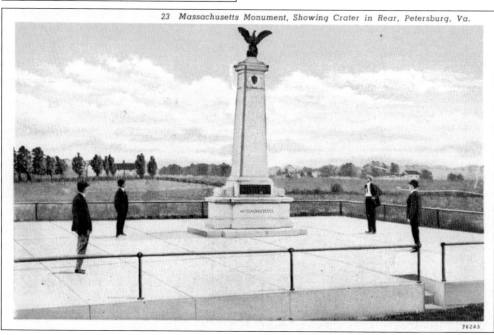

23 Massachusetts Monument, Showing Crater in Rear, Petersburg, Va.

MASSACHUSETTS MONUMENT. Erected by the Commonwealth of Massachusetts, this monument was dedicated on November 13, 1911. Between 1890 and 1927, eleven monuments were erected in and around the Petersburg National Battlefield to commemorate events and participants in the Civil War.

PENNSYLVANIA MONUMENT. On May 19, 1909, President Taft dedicated the Pennsylvania Monument on the site of the Confederate Fort Mahone. The monument, erected by the State of Pennsylvania, commemorates the activities of Maj. Gen. John F. Hartranft's 3rd Division, 9th Army Corps. Hartranft's troops attacked Confederate defenses here on April 2, 1865. The monument's dedication was marked by festivities including a parade and a luncheon and reception attended by President Taft, Gov. Edwin Stuart of Pennsylvania, and Gov. Claude Swanson of Virginia. The earlier postcard of the monument on the right was published by R. R. Totty, a Petersburg druggist who had a store on the corner of Sycamore and Old Streets.

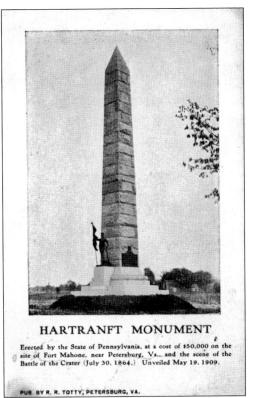

HARTRANFT MONUMENT

Erected by the State of Pennsylvania, at a cost of $50,000 on the site of Fort Mahone, near Petersburg, Va., and the scene of the Battle of the Crater (July 30, 1864.) Unveiled May 19, 1909.

PUB. BY R. R. TOTTY, PETERSBURG, VA.

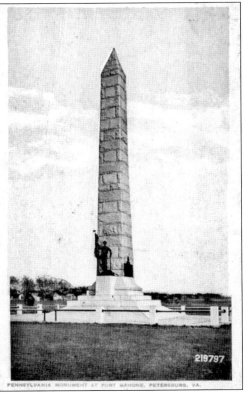

219797

PENNSYLVANIA MONUMENT AT FORT MAHONE, PETERSBURG, VA.

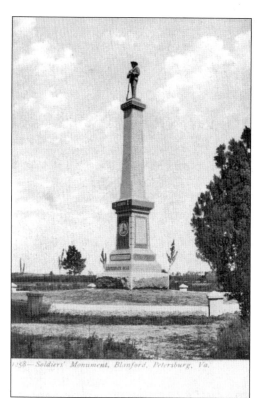

SOLDIER'S MONUMENT, BLANDFORD CEMETERY. Located atop Memorial Hill in Blandford Cemetery, this monument was erected by the Ladies Memorial Association and dedicated on June 9, 1890. Members of the association organized and funded the reinterment of thousands of Confederate soldiers; many of the bodies were reburied on Memorial Hill. Nearly 10,000 people attended the monument dedication, including Virginia governor Philip McKinney and Lucy Lee Hill, daughter of Gen. A. P. Hill.

Confederate Memorial Arch, Blandford Cemetery, Petersburg, Va.

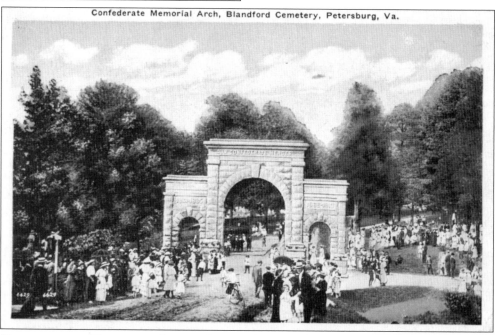

CONFEDERATE MEMORIAL ARCH. On June 9, 1914, this granite arch at the entrance of Memorial Hill was dedicated. Funds were raised by the Ladies Memorial Association to erect the granite structure that measures 30 feet high and 40 feet wide. This arch replaced an earlier, iron, Gothic-style arch that had stood at the site.

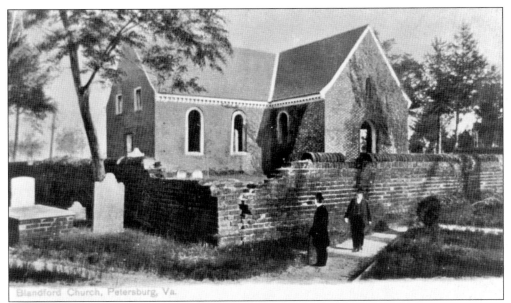

BLANDFORD CHURCH. Located within Blandford Cemetery, this postcard shows the partially restored church that had originally been built in 1735. The church's original congregation moved to a new location in Petersburg in 1805. In 1901, the Ladies Memorial Association obtained permission from the City of Petersburg, the building's owner, to fully restore the church for use as a memorial chapel.

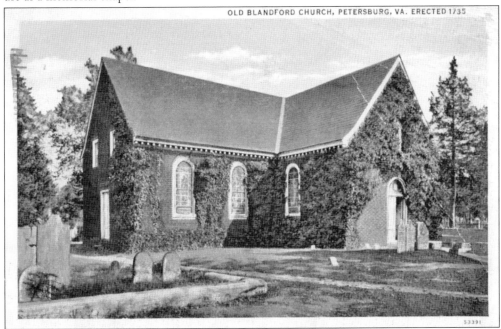

BLANDFORD CHURCH, 1937. As part of the restoration project, the Ladies Memorial Association solicited funds from each former Confederate state and Maryland and Missouri for the creation and installation of a stained-glass window in memory of soldiers from each state. Louis Comfort Tiffany's studio was commissioned to design the 15 windows. The first windows were unveiled in 1904, and the last were installed in 1912.

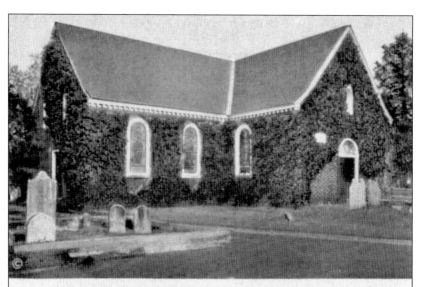

OLD BLANDFORD CHURCH
PETERSBURG, VIRGINIA
Was built in 1735.

The following lines by an unknown author were found written on
its walls about 1841.

Thou art crumbling to the dust, old
 pile,
 Thou art hastening to thy fall,
And 'round thee in thy loneliness
 Clings the ivy to thy wall.
The worshippers are scattered
 now
 Who knelt before thy shrine,
And silence reigns where anthems
 rose,
 In days of "Auld Lang Syne."

And sadly sighs the wandering wind
 Where oft in years gone by.
Prayers rose from many hearts
 to Him
 The Highest of the High:
The tramp of many a busy foot
 That sought thy aisles is o'er,
And many a weary heart around
 Is still forever more.

How doth ambition's hope take
 wing.
 How droops the spirit now;
We hear the distant city's din.
 The dead are mute below.
The sun that shone upon their
 paths
 Now gilds their lonely graves.
The zephyrs which once fanned
 their brows
 The grass above them waves.

Oh! could we call the many back
 Who've gathered here in vain—
Who've careless roved where we
 do now,
 Who'll never meet again;
How would our very hearts be
 stirred
 To meet the earnest gaze
Of the lovely and the beautiful
 The lights of other days.

WM. E. LUM, JR., INC., PETERSBURG, VA. COPYRIGHT 1910

OLD BLANDFORD CHURCH. This poem was found inscribed on the interior of the original church's wall in 1843; the author is unknown. This postcard and the next postcard were published by William E. Lum Jr., a photographer who also owned a stationery and office supply store located on Sycamore Street in Petersburg. By the second quarter of the 20th century, Blandford Church had become a tourist attraction for visitors interested in viewing the Tiffany stained-glass windows. Blandford Church is one of the few buildings in the country to have a set of decorative stained-glass windows that were completely designed, manufactured, and installed under the direction of Louis Comfort Tiffany.

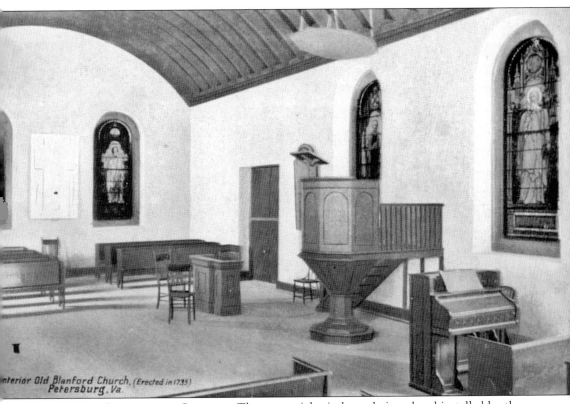

Interior Old Blanford Church, (Erected in 1735)
Petersburg, Va.

INTERIOR OF BLANDFORD CHURCH. The memorial windows designed and installed by the Tiffany studios feature 11 windows on the first floor donated by South Carolina, North Carolina, Louisiana, Virginia, Missouri, Mississippi, Tennessee, Georgia, Florida, Texas, and Alabama. Four smaller windows were designed to complement the larger windows: two were donated by Maryland and Arkansas, one was donated by the Ladies Memorial Association, and the 15th window was a gift from Louis Comfort Tiffany. The windows visible in this postcard from left to right are Missouri, Virginia, Louisiana, and North Carolina. The Virginia, Missouri, and Louisiana windows were the first to be dedicated on June 9, 1904. The Georgia window was the last to be dedicated on November 18, 1912. Between 1899 and 1905, the Ladies Memorial Association also funded construction of a speaker's stand and 34 pews for the interior of the church.

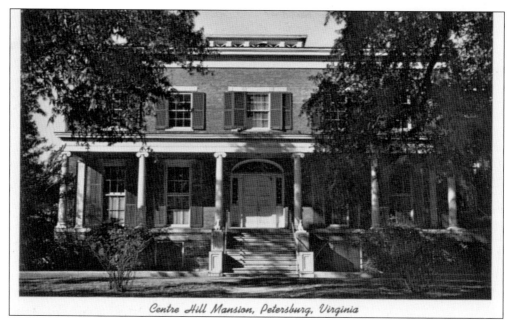

Centre Hill Mansion, Petersburg, Virginia

CENTRE HILL. Built in 1823 by Robert Bolling IV, Centre Hill became headquarters for federal troops under Gen. George L. Hartsuff on April 5, 1865. Two days later, President Lincoln visited the house to meet with the general. In 1901, Centre Hill was purchased by Charles Hall Davis, a Petersburg attorney. The Davis family hosted a luncheon for President Taft on May 19, 1909, following the dedication of the Pennsylvania monument.

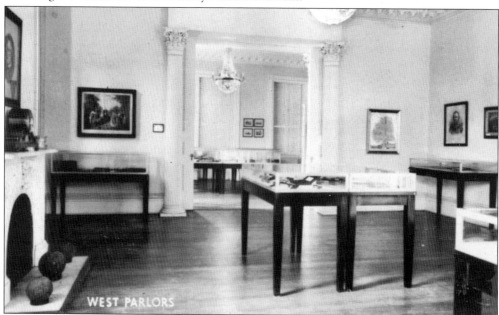

WEST PARLORS

CENTRE HILL CIVIL WAR MUSEUM. In 1949, the Petersburg Battlefield Museum Corporation was incorporated to operate a Civil War museum in the house. The museum opened on April 22, 1950, and the property was officially deeded to the corporation in 1952. In 1972, the house was turned over to the City of Petersburg, who renovated the structure and reopened the site as a historic house museum.

Two

COMMERCIAL
STREET SCENES

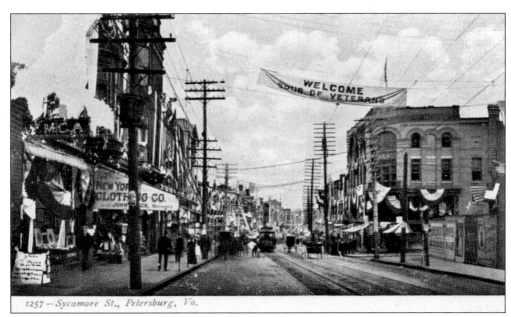

1257 — Sycamore St., Petersburg, Va.

SYCAMORE STREET. Dating from before 1907, this is an early postcard view of Sycamore Street. Throughout the 19th and into the early 20th century, the street was built up southward in stages. Electric streetcar lines were established in the early 1890s. The building in the right background was Moses Saal's department store, located on the corner of Sycamore and East Tabb Streets. Several years later, the building would become home to the Globe Department Store. The New York Clothing Company, on the left, was established in 1897. The sign for the first YMCA location in Petersburg is in the left foreground.

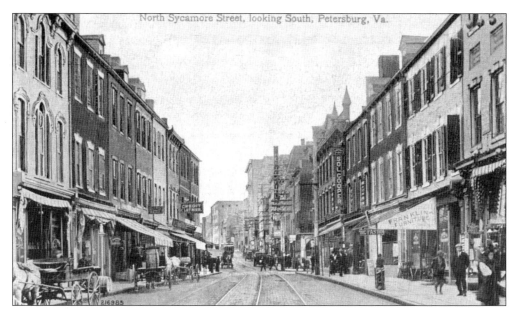

NORTH SYCAMORE STREET, LOOKING SOUTH. This view printed around 1915 shows Sol Cooper's department store on the left. The establishment specialized in women's apparel, evening gowns, and wraps. The Fashion, located between Sol Cooper's and Franklin Furniture Company, sold millinery and shoes. The sign for the Chesterfield Hotel is in the background. In 1913, the hotel was renovated and advertised as the New Chesterfield Hotel. (Postcard courtesy of Russell W. Davis.)

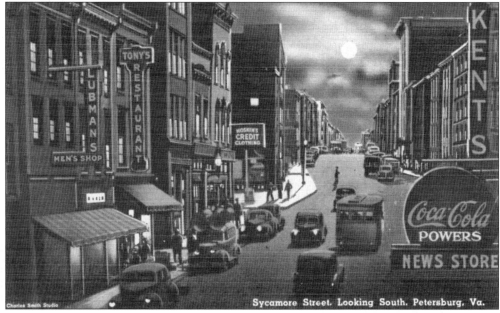

SYCAMORE STREET, LOOKING SOUTH. Published around 1943, this view shows businesses along a busy strip of Sycamore Street. Courthouse Avenue is located behind Moskins Credit Clothing. The Powers News Store at 242 North Sycamore Street was a popular gathering place for all ages; the business sold soft drinks and ice cream in addition to newspapers. Kent's Furniture Company, located at 228–230 North Sycamore Street, sold furniture and appliances.

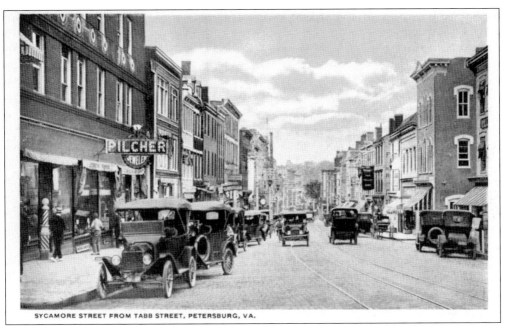

SYCAMORE STREET FROM TABB STREET, PETERSBURG, VA.

SYCAMORE STREET FROM TABB STREET. In 1910, the city began replacing cobblestone street surfaces with granite blocks that facilitated smoother automobile travel. This view published around 1922 shows Pilcher's jewelry store, located on the ground floor of the Mechanic's Association Building. Mr. Pilcher established his business in 1904. In addition to offering watchmaking, repairing, and engraving services, he was the official inspector for the watches of the Atlantic Coast Line Railroad.

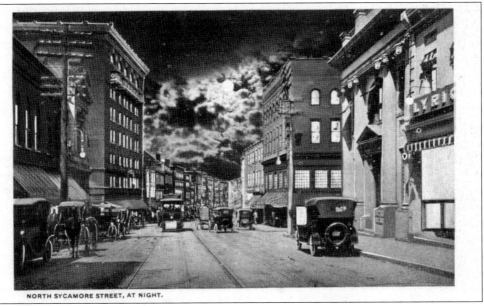

NORTH SYCAMORE STREET, AT NIGHT.

SYCAMORE STREET AT NIGHT. The Lyric Theatre, partially visible in the right foreground, opened in 1909 and had a seating capacity of 600. The theater hosted vaudeville acts and film screenings. The National Bank of Petersburg building is next to the theater. In the mid-ground are the Mechanic's Association Building on the left and the Globe Department Store on the right.

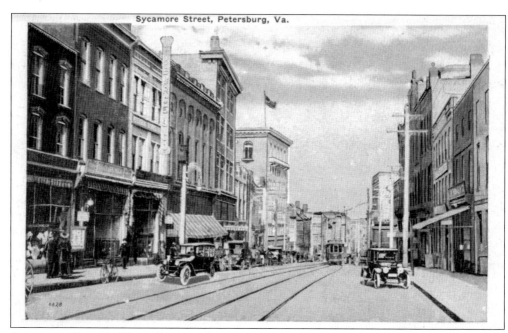

SYCAMORE STREET. The J. O. James Shoe Company was located in the first complete building on the left in this 1915–1916 view. The business, established in 1882, sold men's and women's footwear and leather goods. The W. Y. Burge men's clothing store and the Petersburg Business College both occupied the adjoining building on the right, located at 126 North Sycamore Street.

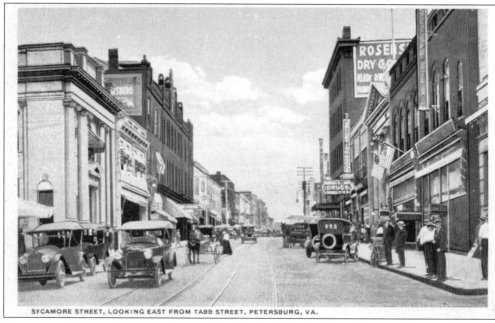

SYCAMORE STREET, LOOKING EAST FROM TABB STREET, PETERSBURG, VA.

SYCAMORE STREET, LOOKING SOUTH. The National Bank of Petersburg and the Lyric Theatre are in the left foreground. Businesses on the right include Rosenstock's Dry Goods Store, James Branch Sporting Goods, and the Rexall Drug Store. The columns and triangular pediment of the Virginia National Bank are also visible in the center of the block. This postcard was printed around 1916—note the horse and buggy behind the automobile.

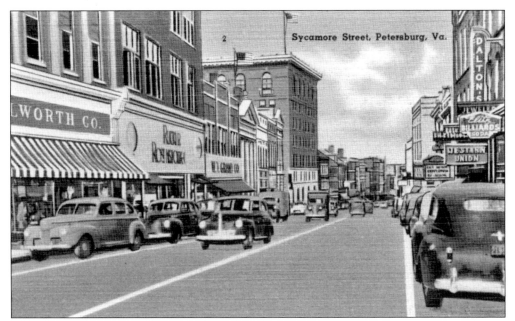

SYCAMORE STREET. This 1940s view shows many of the same buildings as the previous postcard. Rucker Rosenstock's department store was located between the national chain of F. W. Woolworth Company and the W. T. Grant Company department store. The opposite side of the street contained the Elite Billiards parlor, a branch of Western Union, and Dalton's Jewelers. The Palace Motion Picture Theatre had replaced the Lyric.

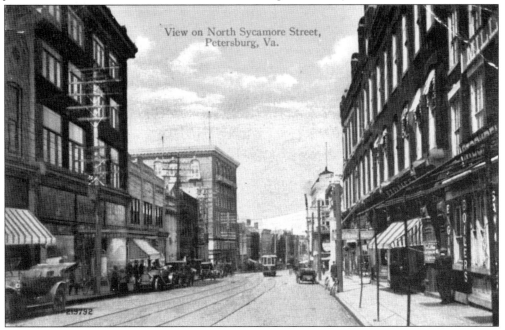

SYCAMORE STREET C. 1915. The Stockdale Meyers Hardware Company, in the immediate right foreground, sold and repaired agricultural and mill machinery and portable engines. Neighboring businesses included T. S. Beckwith, a stationery, office supply, and musical instrument retailer; and the Petersburg branch of Western Union, the telegraph and money transfer company.

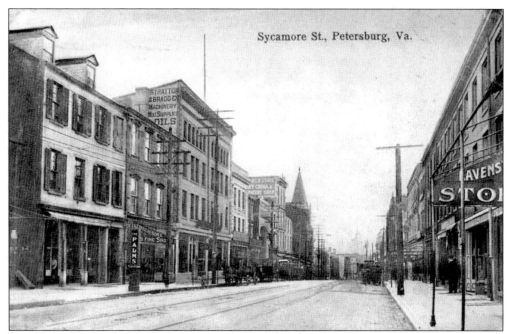

Sycamore St., Petersburg, Va.

SYCAMORE STREET, C. 1910. Housed in the first building on the left, the Palms was an ice-cream parlor and candy store that attracted customers from all over Southside Virginia. Reinach and Sons shoe store was located next to the Palms. Stratton and Bragg machinists and mill suppliers advertised on the side of their neighboring, four-story building. The Lavenstein's department store sign is partially visible in the right foreground.

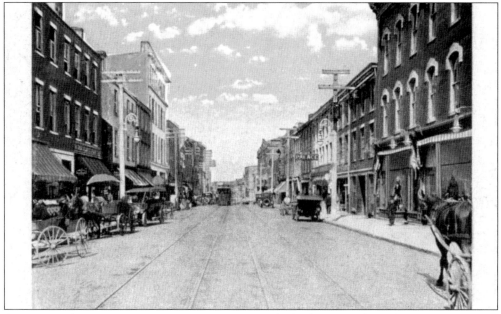

SYCAMORE STREET FROM FRANKLIN STREET. The building on the right was home to the Applefelt Brothers' department store in 1915. The Palace Theatre was located in the center of this block. Other businesses in this block during that era included the Petersburg Furniture Company, the Queen City Confectionary Company, and the Great Atlantic and Pacific Tea Company.

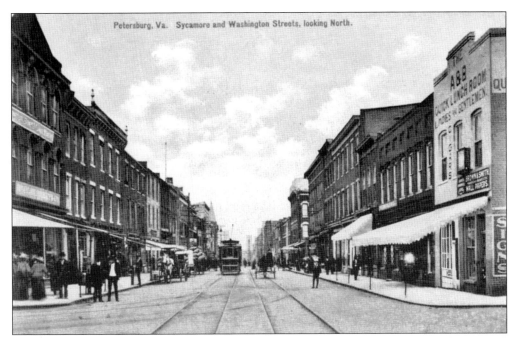

SYCAMORE AND WASHINGTON STREETS LOOKING NORTH. Businesses on this corner around 1910 included the Harlow Hardy Furniture Company, the A&B Quick Lunchroom, and Brown and Smith Wallpapers. The A&B Quick Lunchroom, later called the A&B Restaurant, would occupy the corner of Sycamore and Washington Streets for a large part of the 20th century.

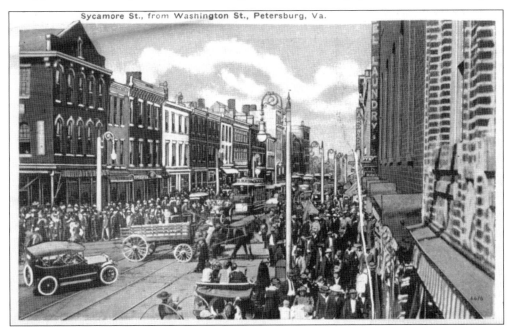

Sycamore St., from Washington St., Petersburg, Va.

SYCAMORE STREET FROM WASHINGTON STREET. This view, published approximately 10 years after the postcard above, shows the addition of lampposts along Sycamore Street. The Model Steam Laundry, whose sign is partially visible on the right, was established in 1896. Its plant was outfitted with conveyor dry rooms, electric irons, and press machines.

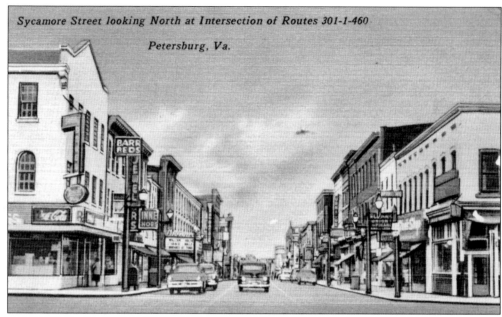

Sycamore Street looking North at Intersection of Routes 301-1-460

Petersburg, Va.

SYCAMORE STREET LOOKING NORTH FROM THE INTERSECTION WITH WASHINGTON STREET. The movie title on the Bluebird Theater marquee in the left mid-ground of the top postcard dates the image to 1955. The film playing at that time was *The Bridges of Toko-Ri*, starring William Holden and Grace Kelly. With the exception of the Bluebird Theater, many of the same businesses can still be seen on this block of Sycamore Street in the 1960s-era postcard below. These establishments included the Rexall Drug Store, Barr Brothers Jewelers, and Kinney Shoes on the left, and Union Finance and Small Loan Corporation and Love-Hudgins furniture store on the right. By 1960, the Bluebird Theater had moved to 143 North Sycamore Street, formerly the Lyric Theatre building, where it remained in business for approximately 20 more years.

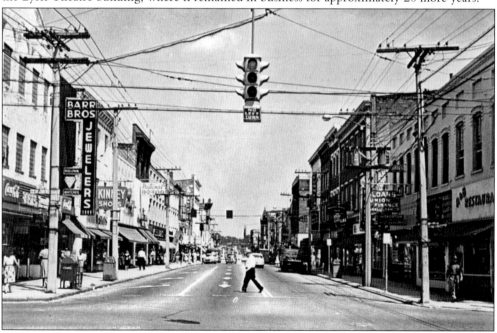

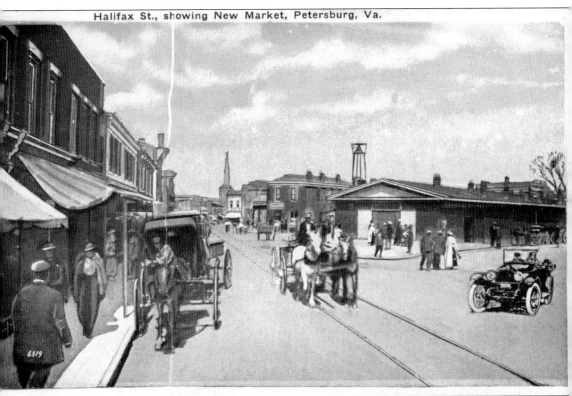

HALIFAX STREET. The intersection of South Avenue, Halifax, and Harrison Streets, known as the Triangle, was the center of Petersburg's African American business district for nearly a century. In the last quarter of the 19th century, laws were passed in the South restricting the rights of African Americans, and in 1896, the Supreme Court ruled that separate but equal public facilities were legal. Like in many Southern communities, African Americans in Petersburg reacted to segregation by creating a separate society that included businesses as well as cultural establishments. The one-story building in the mid-ground was the New Market. In operation until about 1950, the market was occupied by grocery vendors and produce sellers. Other businesses in the Triangle included Wilkerson's Funeral Home, established in 1874; the Rialto Theater, built in 1923; Club Chatterbox; and banks, barbershops, drugstores, and tailors. The Triangle is located at the tip of a neighborhood known as Ravenscroft. Incorporated into Petersburg in 1784, Ravenscroft is bordered by Halifax Street, a major transportation route in the 18th and early 19th centuries that linked Petersburg with North Carolina.

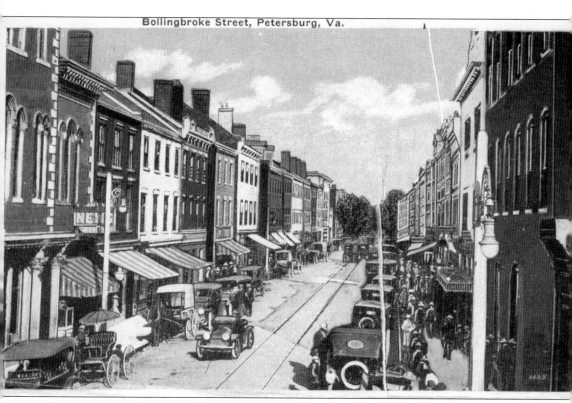

BOLLINGBROOK STREET. Although the postcard title is spelled incorrectly, this image captures the lively atmosphere on Bollingbrook Street around 1920. In the early 19th century, Bollingbrook was the principal street in Petersburg, and in 1813, it was the first street to be surfaced. The partial facade seen in the left foreground was originally built as Library Hall by the Petersburg Library Association after their original building on the site burned shortly after the Civil War. The association sold the building in 1879. The Virginia Railway and Power Company owned the building during the early 20th century and used it as a passenger station for their Petersburg-to-Richmond trolley line. The structure was demolished in 1932. Today two of the remaining historic structures on Bollingbrook Street are the Farmer's Bank building, erected in 1817, and the Nathaniel Friend House, constructed in 1816. Both are visible in the left mid-ground of this postcard. Many of the buildings on Bollingbrook Street had shops on the first level and residences above.

Three

EDUCATIONAL
INSTITUTIONS

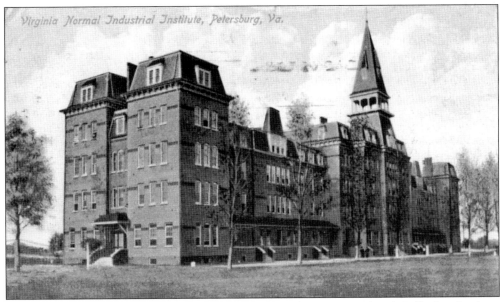

VIRGINIA NORMAL INDUSTRIAL INSTITUTE. The Virginia Normal and Collegiate Institute was chartered by the state in 1882 to provide post-secondary education for African Americans. Thirty-three acres of farmland were purchased on the north side of the Appomattox River opposite of Petersburg for the school's campus. On July 4, 1883, the cornerstone for Virginia Hall, the building seen in this postcard, was laid. The inaugural academic year began on October 1, 1883, with 126 students and 7 faculty members. In 1902, the school's charter was revised and its name changed to the Virginia Normal and Industrial Institute. Virginia Hall was demolished in 1935 due to structural problems.

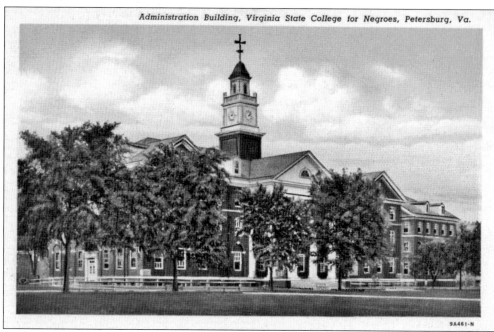

Administration Building, Virginia State College for Negroes, Petersburg, Va.

VIEWS OF CAMPUS, VIRGINIA STATE COLLEGE FOR NEGROES. In 1930, the Virginia Normal and Industrial Institute became Virginia State College for Negroes. The institution had reinstated a collegiate program in 1923. These postcards were printed in the 1930s after the campus had added several new buildings. The building in the top postcard, also named Virginia Hall, replaced the former Virginia Hall as the campus's central administration building. In the bottom postcard, Byrd Hall, a women's dormitory, is on the left. The building in the foreground was the original library on campus. Trinkle Hall, seen in the right background, was also a dormitory.

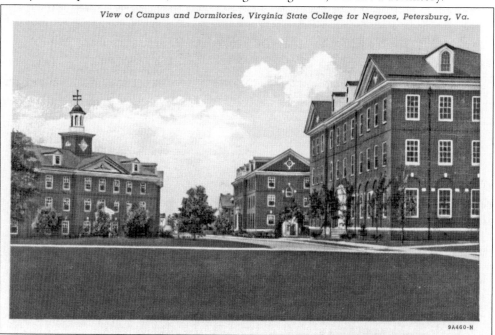

View of Campus and Dormitories, Virginia State College for Negroes, Petersburg, Va.

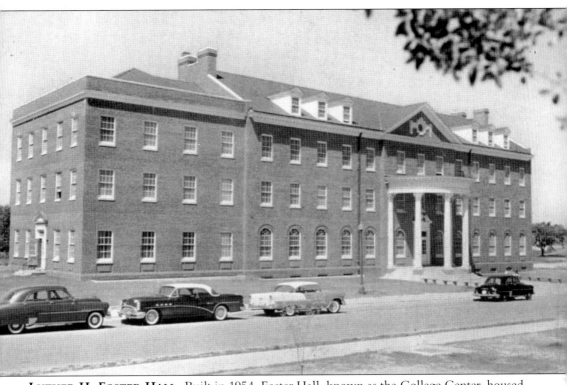

LUTHER H. FOSTER HALL. Built in 1954, Foster Hall, known as the College Center, housed recreational facilities, the audio-visual center, and the foreign language laboratory. Luther H. Foster served as president of the college from 1942 to 1949. In 1946, the school was renamed Virginia State College, and in 1979, it became Virginia State University.

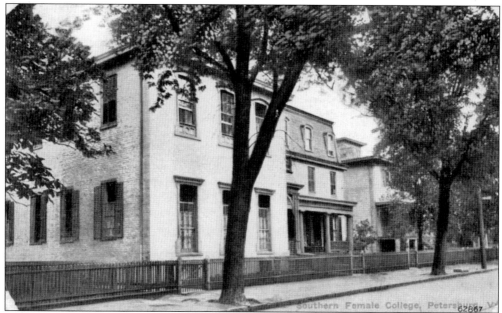

SOUTHERN FEMALE COLLEGE. This institution was chartered by the Confederate legislature in 1863. Located at 214–224 South Sycamore Street, the privately funded school offered junior college and college preparatory programs. The main building shown on the postcard had parlors, a social hall, and a library on the first floor and dorm rooms on the second. Later known as Southern College, the school was in operation for approximately 75 years.

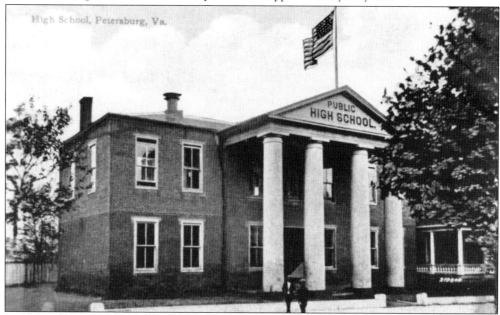

PETERSBURG PUBLIC HIGH SCHOOL. The city's first public high school, established in 1868, was located in the former Petersburg Classical Institute on Union Street. In the first decade of the 20th century, the school moved to West Washington Street. For nearly 100 years, Petersburg's school board operated a segregated school system. In 1874, African Americans were given the opportunity for secondary education when Peabody High School opened its doors.

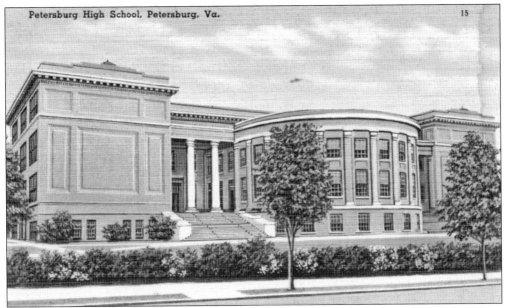

PETERSBURG HIGH SCHOOL. Completed in 1918, the new school building was built on West Washington Street on the site of an antebellum school. By 1934, the floor plan included biology, chemistry, and physics labs on the third floor; eight classrooms, the library, a sewing room, and a dental room on the second floor; and eight classrooms and an auditorium with a seating capacity of 1,072 on the first floor. The basement of the building contained the gymnasium, a locker room, two cafeterias, and additional classrooms. In 1970, the Petersburg school board ruled to formally desegregate the school system, allowing all 10th-, 11th-, and 12th-grade students from the city to attend Petersburg High School. Several years later, the school moved to a new facility. In 2000, the former school building became the home of the Appomattox Regional Governor's School.

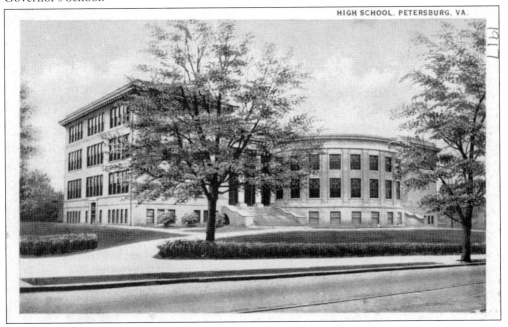

HIGH SCHOOL, PETERSBURG, VA.

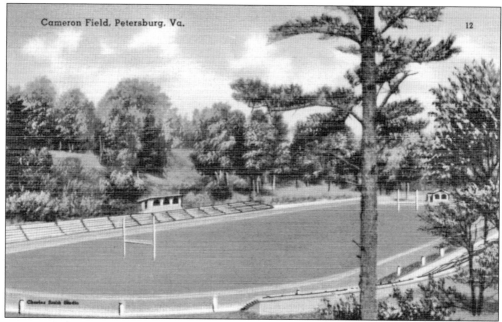

Charles Smith Studio

CAMERON FIELD. Although these postcards were printed nearly 30 years apart, they both feature an almost identical vantage point. The same caption, "One of the most beautiful natural athletic bowls in the South," also appears on the reverse of each card. In 1931, the heirs of George Cameron gave Petersburg 21 acres with the request that the land be utilized as an athletic field. In the field's early years, the field house had been located in what had originally been stables. Petersburg Hospital, visible in the background of the bottom postcard, was built in 1951 on the site of Mount Erin, the former residence of George Cameron's brother. Several generations of Petersburg High School students utilized this playing field, most notably for home football games and graduation ceremonies.

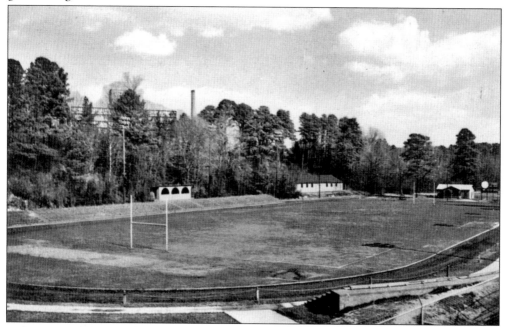

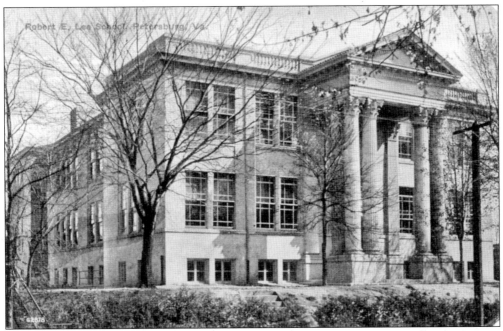

ROBERT E. LEE SCHOOL. Built between 1910 and 1911 at 637 West Washington Street, at the time of its opening, this school was one of five elementary schools for white students in the city. This postcard was printed around 1914. By 1934, the building housed 15 classrooms. The building was converted into apartments in 2001.

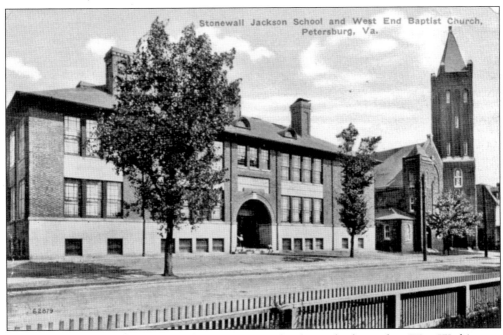

STONEWALL JACKSON SCHOOL. This elementary school was also located on West Washington Street. Classrooms were located on two floors, and an auditorium was also on the second floor. The school remained open until the 1970s. The building was demolished in 1996.

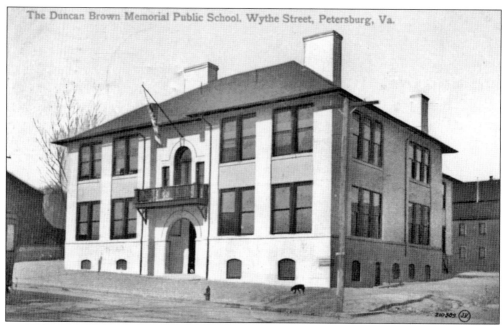

The Duncan Brown Memorial Public School, Wythe Street, Petersburg, Va.

DUNCAN BROWN MEMORIAL PUBLIC SCHOOL. Named for Petersburg's school superintendent from 1886 to 1908, the elementary school located on Wythe Street was described upon completion in 1908 as being one of the most modern school buildings in the state. Educators from throughout Virginia toured the facility to utilize it as a model to pattern the design of future school buildings.

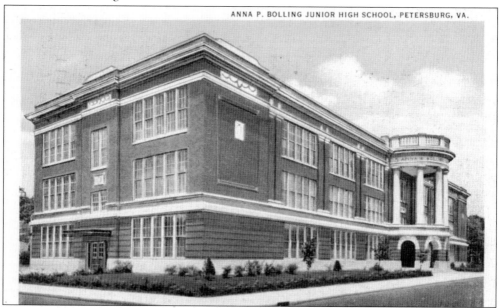

ANNA P. BOLLING JUNIOR HIGH SCHOOL, PETERSBURG, VA.

ANNA P. BOLLING JUNIOR HIGH SCHOOL. Built on the site of the original Peabody High School for African Americans, Bolling Junior High School was dedicated in 1927. Miss Anna Bolling had been a teacher and later principal of Petersburg High School from 1868 to 1907. In addition to classrooms, the school contained a science laboratory and an auditorium with a seating capacity of 920.

Four

Churches, Charitable Institutions, and Cemeteries

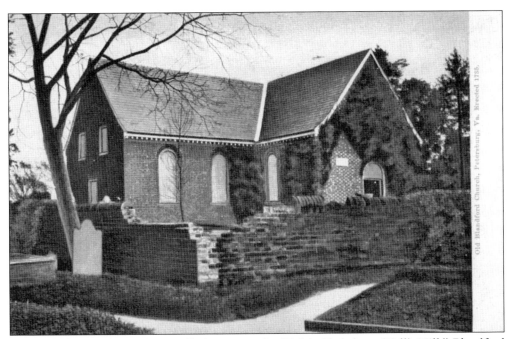

BLANDFORD CHURCH. Originally known as the "Brick Church on Well's Hill," Blandford Church was built in 1735 as the seat of worship for members of the surrounding Bristol Parish. Established by the House of Burgesses in 1643, the parish served colonists who were members of the Anglican Church. Following the Revolution, the Anglican Church was disbanded, and a new Episcopal church was built in Petersburg in 1805.

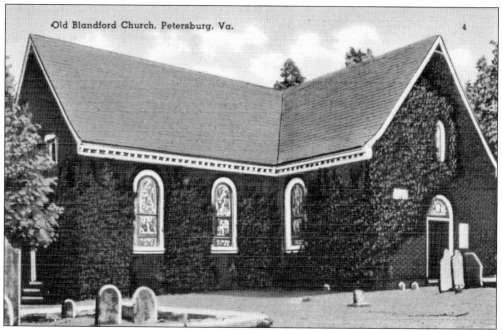

Old Blandford Church, Petersburg, Va.

4

OLD BLANDFORD CHURCH. In 1819, the abandoned church and surrounding burial grounds were conveyed to the City of Petersburg. The church was partially restored in 1882 and fully restored between 1904 and 1912, during the period that the Ladies Memorial Association sponsored the installation of the 15 memorial stained-glass windows by Louis Comfort Tiffany. Both of these postcards were produced during the 1930s or 1940s. Throughout the 20th century and into the 21st century, the church has been utilized for secular gatherings, including the annual June 9 commemoration of the Battle of Old Men and Young Boys. Since 1972, the church has been open to the public under the auspices of the city's department of tourism.

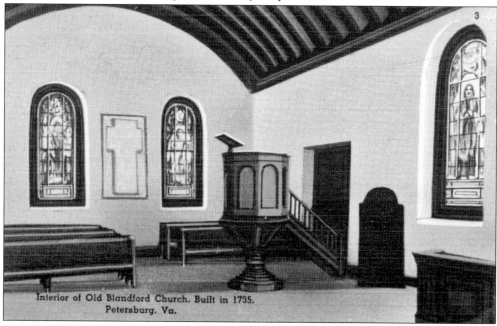

Interior of Old Blandford Church. Built in 1735, Petersburg, Va.

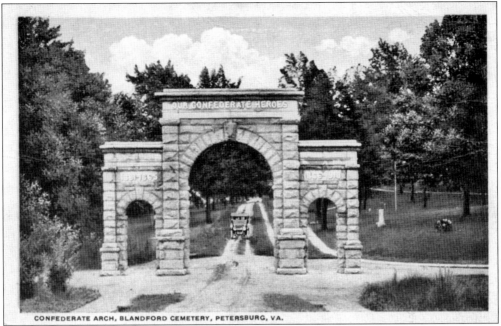

CONFEDERATE ARCH, BLANDFORD CEMETERY, PETERSBURG, VA.

BLANDFORD CEMETERY. The cemetery surrounding Blandford Church has been used as a burial ground since the 18th century. Maj. Gen. William Phillips, commander of the British troops during the April 25, 1781, Battle of Petersburg, was buried in an unmarked grave in the cemetery after his death from illness on May 13, 1781. The cemetery was acquired by the City of Petersburg for use as a municipal burying ground in 1819. As many as 30,000 Confederate soldiers are buried on Memorial Hill, whose entranceway is marked by the arch in the top postcard. In 1868, the cemetery became the inspiration for the national Memorial Day after a high-ranking military official's wife noticed the Confederate graves decorated with small flags, flowers, and wreaths. The 189-acre burial ground remains an active cemetery today.

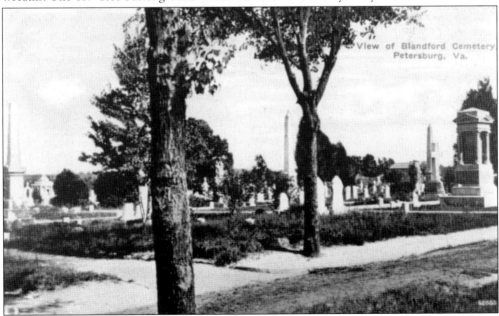

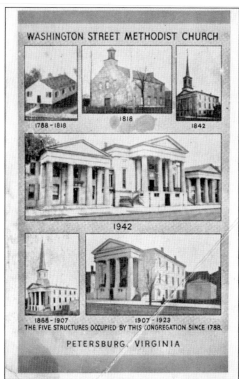

WASHINGTON STREET METHODIST CHURCH

1788-1818 1818 1842

1942

1888-1907 1907-1923

THE FIVE STRUCTURES OCCUPIED BY THIS CONGREGATION SINCE 1788.

PETERSBURG, VIRGINIA

WASHINGTON STREET METHODIST CHURCH. The church's current building on Washington Street was dedicated in 1842. Tradition states that the congregation's first building, constructed in 1744 on Harrison Street, was burned by British troops during the Revolutionary War. The first and second images on this card show the congregation's 1788–1818 location on the corner of North Market and Friend Streets and the 1818 building on Union Street.

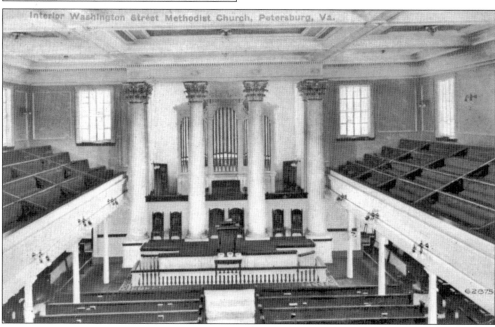

INTERIOR, WASHINGTON STREET METHODIST CHURCH. The church building was first renovated in 1888 and 1907. This postcard was printed after 1907. In 1923, the congregation significantly enlarged the building, making it one of the most spacious worship facilities in the South. During World War II, the church was used as a blood center; 5,815 pints of blood were donated to the armed forces.

ST. PAUL'S EPISCOPAL CHURCH. St. Paul's congregation descended from the 18th-century parishioners who originally worshipped in Blandford Church. In 1805, their first church in Petersburg was built on the site of the courthouse. Their current building, seen here, was completed around 1857. General Lee worshipped here during the Siege of Petersburg. The wedding of Lee's son to a Petersburg bride took place in the church in 1867.

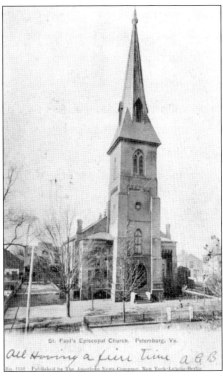

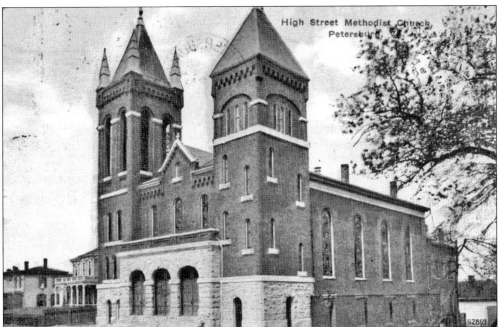

HIGH STREET METHODIST CHURCH. Construction of this church building was begun in 1844, after the 832 members of the original Methodist church had divided into eastern and western geographic regions. Washington Street Methodist Church became the eastern church, and High Street served parishioners living in the western part of the city. The two towers flanking the entrance were added in 1899 as part of an extensive renovation project.

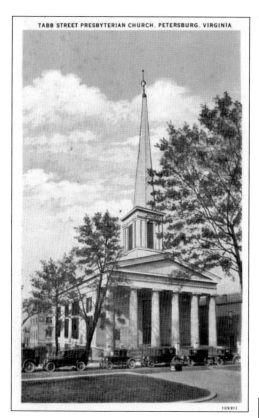

TABB STREET PRESBYTERIAN CHURCH, PETERSBURG, VIRGINIA

TABB STREET PRESBYTERIAN CHURCH.
Designed by Thomas U. Walter in the Greek
Revival style, this building was completed in
1844. Walter also served as an architect for the
U.S. Capitol building. A tunnel underneath
the building's front porch was used as a shelter
from artillery fire during the Civil War. This
postcard was printed before the church's
steeple was removed in 1938, after it was
determined to be structurally unsound.

SECOND PRESBYTERIAN CHURCH. The
congregation moved to its present location
at the corner of Washington and Lafayette
Streets in 1862. During the siege, an
artillery shell burst through a wall of the
church while a service was being conducted.
On April 3, 1865, the body of a dead
Confederate soldier was discovered propped
up against the building and was buried in
the churchyard.

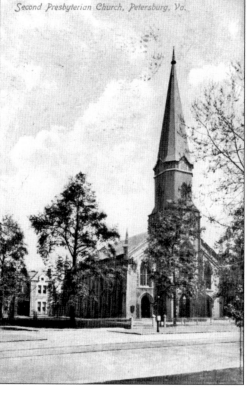

Second Presbyterian Church, Petersburg, Va.

ST. JOSEPH'S CATHOLIC CHURCH. This church building was erected on the site of the congregation's original building at the corner of West Washington and Market Streets. The first church had been completed in 1842. The cornerstone for the new church building was laid on July 1, 1894. Special trains ran from Norfolk and Richmond to bring attendees to the cornerstone dedication ceremony. The first service was held in the newly completed sanctuary on January 12, 1896. The top postcard, printed around 1907, shows the train tracks in the foreground that led to the Atlantic Coast Line Railroad Depot on Sycamore and Washington Streets.

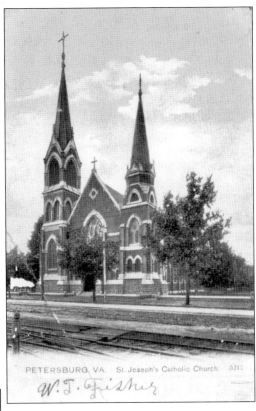

PETERSBURG, VA. St. Joseph's Catholic Church. 6211

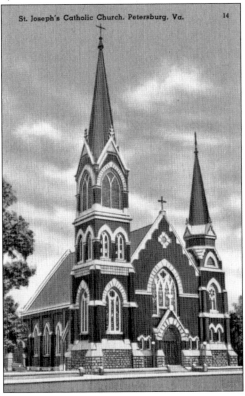

St. Joseph's Catholic Church. Petersburg, Va. 14

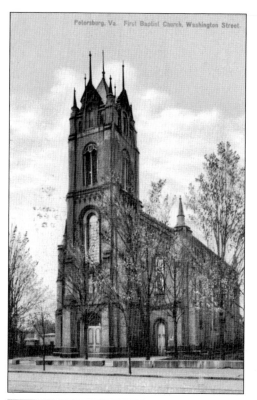

FIRST BAPTIST CHURCH, WASHINGTON STREET. This church was formed in 1817. In 1841, the congregation moved to the corner of North Market and High Streets. Several years later, a building was built on West Washington Street. The church building seen in this 1912 postcard was the second building the congregation built on the site. It was demolished and replaced with a new building in 1931.

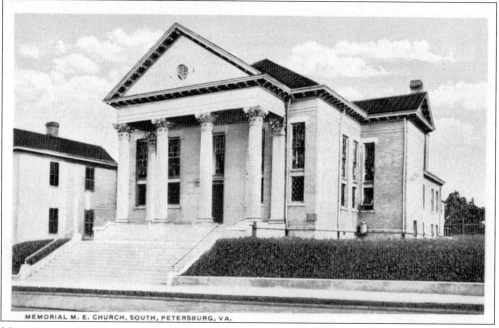

MEMORIAL METHODIST EPISCOPAL CHURCH. This building, located on West Washington Street, was completed in 1913. In the church's early years, the congregation consisted mainly of residents from the Battersea section of Petersburg. By 1913, the church had 432 members. The size of the congregation had doubled by 1921, when membership reached 864 parishioners.

SECOND BAPTIST CHURCH. The congregation of this church formed in 1854 as the Byrne Street Baptist Church. This building, located on South Sycamore Street near the present-day intersection of Wythe Street, was built in 1897. In 1965, the church was demolished due to city projects. The congregation relocated to a new building on Johnson Road.

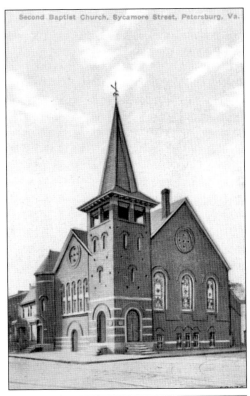

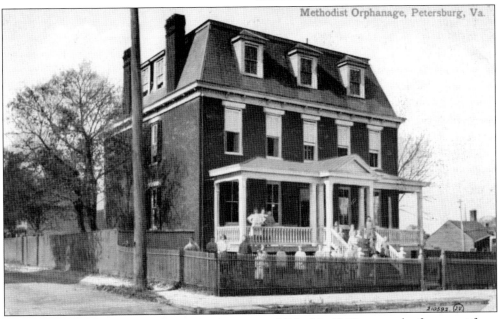

METHODIST ORPHANAGE. This institution was established in 1847 as a result of a request from a dying son of Irish immigrants. Before his death in 1845, 14-year-old Thomas Cooke Paul asked that his share of the family estate be used for the establishment of a home for orphans. The orphanage continued to operate by various names well into the 20th century on South Sycamore Street.

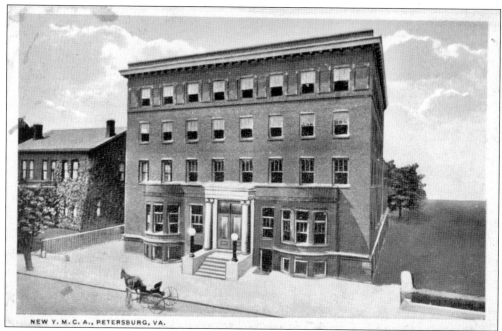

NEW Y. M. C. A., PETERSBURG, VA.

YMCA. This was the second location for the Petersburg branch of this worldwide organization. The building was built around 1915 on the site of the former Petersburg Classical Institute building on Union Street; the site also housed Petersburg's first public high school. The YMCA's first chapter in Petersburg opened on Sycamore Street during the last quarter of the 19th century. The organization would later move to its current location on Madison Street.

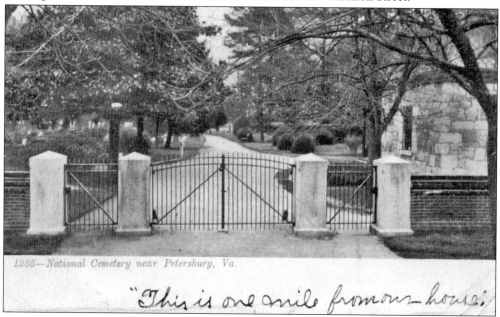

1255—*National Cemetery near Petersburg, Va.*

"This is one mile from our house."

POPLAR GROVE NATIONAL CEMETERY. In 1866, the U.S. Burial Corps began the task of moving the remains of nearly 6,000 federal soldiers killed during the Petersburg campaign to this newly established national cemetery located near Petersburg. Burial of Civil War soldiers continued until June 1869. Veterans of other wars continued to be buried at the cemetery until 1957.

Five

RECREATION AND OUTDOOR LIFE

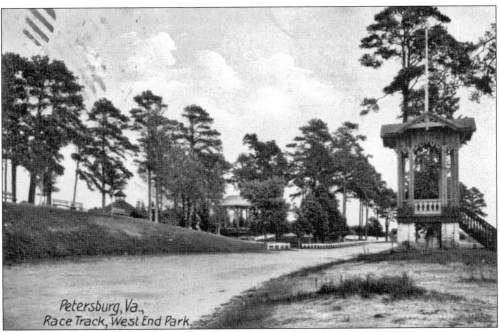

Petersburg, Va.,
Race Track, West End Park.

WEST END PARK, RACE TRACK. In the 18th and 19th centuries, horse racing was a popular pastime in Petersburg. After the Revolutionary War, at least four racetracks existed in Petersburg. The track at West End Park was most likely the last to survive into the 20th century. During the Civil War, the grounds of West End Park were used as a hospital. Later, in the 20th century, the park became home to Petersburg's fairgrounds.

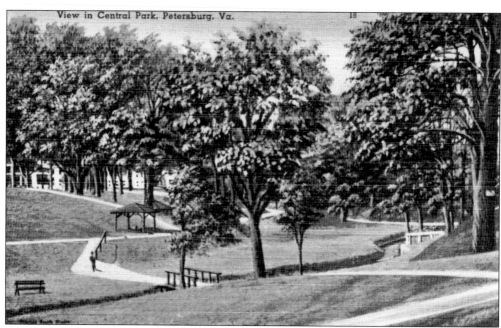

View in Central Park, Petersburg, Va. 18

VIEWS IN CENTRAL PARK. This expanse of land between Sycamore and Jefferson Streets originally served as drilling grounds for local military units. The City of Petersburg purchased the land from George W. Bolling in 1846 for the sum of $15,000. In August 1848, a reception was given here to welcome home local veterans of the Mexican War. Thirteen years later, on April 19, 1861, a battalion of Virginia Volunteers camped on the lawn on the eve of their departure for service in the Civil War. A hospital for Confederate soldiers was located in the park from 1862 until 1864. Wounded federal troops were also treated on the grounds after the Battle of the Crater.

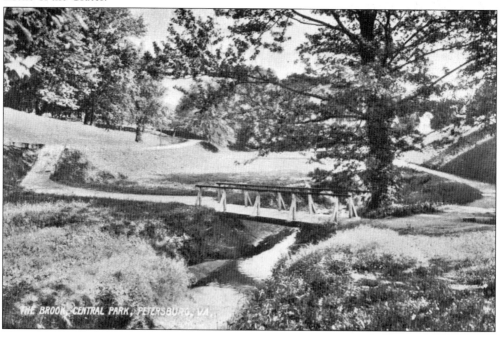

THE BROOK, CENTRAL PARK, PETERSBURG, VA.

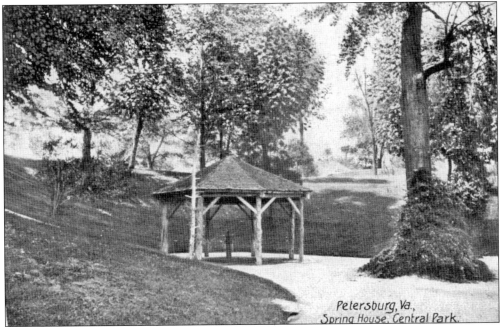

Petersburg, Va.,
Spring House, Central Park.

IN CENTRAL PARK. In the 1870s, walkways, fountains, and a lake stocked with goldfish were built inside the park. Originally called Poplar Lawn, the park's name was changed to Central Park in 1881. In 1934, the city council endorsed an action to restore the park's name back to Poplar Lawn. Structures in the park include a spring house and a cottage that housed the caretaker's office and a public restroom. Many single-family residences were built along the edge of Poplar Lawn in the 19th century. The top postcard is postmarked 1909, and the bottom postcard dates from the first quarter of the 20th century.

IN CENTRAL PARK, PETERSBURG, VA.

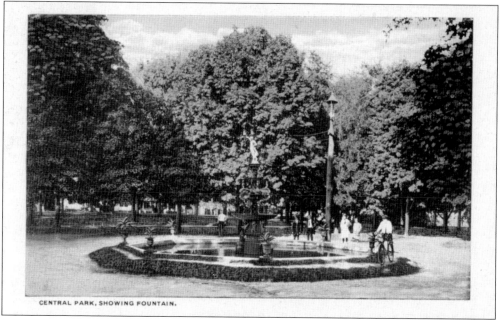

CENTRAL PARK, SHOWING FOUNTAIN.

CENTRAL PARK FOUNTAIN. The fountain was added in the last quarter of the 19th century. By 1875, 500 trees had been planted in the park. For many years, the park was the setting for a Fourth of July celebration. The park was accessible by streetcar, making it an easy destination to get to in the late 19th and early 20th centuries, before the majority of the population owned automobiles.

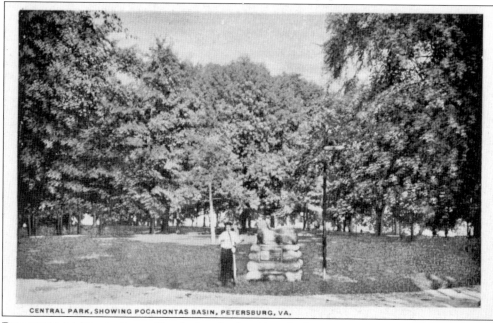

CENTRAL PARK, SHOWING POCAHONTAS BASIN, PETERSBURG, VA.

POCAHONTAS BASIN. Legend has it that the American Indian princess Pocahontas once bathed from this basin. Originally located on the banks of the Appomattox River, the basin was moved several times before it was placed in Central Park, now known as Poplar Lawn. Research indicates that it is doubtful that Pocahontas utilized the basin, but tourists have been enthralled with the rock formation for over a century.

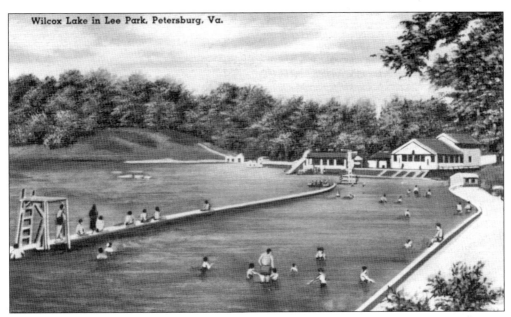

Wilcox Lake in Lee Park, Petersburg, Va.

WILCOX LAKE. Originally a stream called Wilcox Branch, the lake was formed when the city built a dam to create a reservoir. The city had purchased 1,700 acres that included the Wilcox Branch watershed in 1893. In 1921, the city designated a 462-acre parcel as a park named after Gen. Robert E. Lee. The lake's swimming facilities featured a beach, lifeguard station, bathing pavilion, and bathhouses. However, the park's recreational facilities, including the swimming area, were segregated and off-limits to Petersburg's African American community. In 1953, a group of African American citizens filed a petition to integrate the swimming facilities. The Petersburg City Council ruled to close the swimming area. While other recreational facilities at the park were integrated, the swimming facilities never reopened.

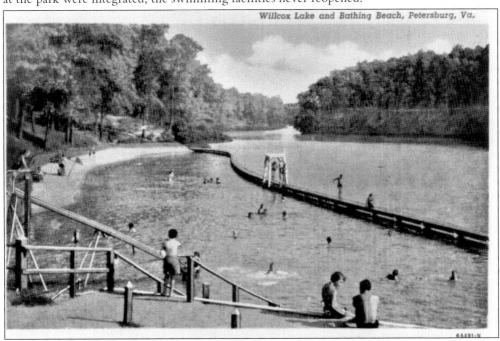

Willcox Lake and Bathing Beach, Petersburg, Va.

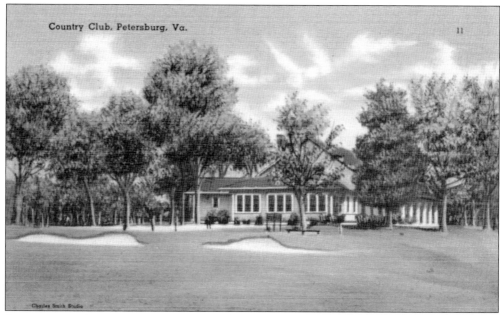

Country Club, Petersburg, Va.

11

PETERSBURG COUNTRY CLUB. In 1921, the Petersburg Country Club was established on 50 acres of land north of Wilcox Lake. Shortly after its founding, a golf course and a clubhouse were built. At least two other golf courses existed for Petersburg players in the first third of the 20th century. The Riverside Country Club, off Cox Road in Dinwiddie County, opened in 1901. The club featured a golf course as well as tennis courts, a grandstand, and an enclosed horse track. In 1913, the grandstand, along with the club's stables, was destroyed by fire. The remaining buildings and grounds were sold at auction. In 1926, the Crater Battlefield Association constructed a golf course on land adjacent to the crater. The battlefield course remained open until the effects of the Depression forced it out of business in 1934.

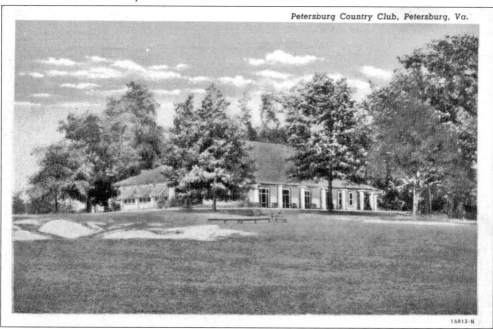

Petersburg Country Club, Petersburg, Va.

Six

MUNICIPAL AND PUBLIC BUILDINGS

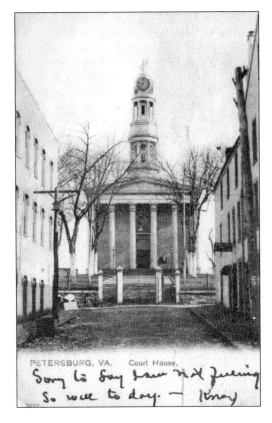

PETERSBURG, VA. Court House.

PETERSBURG COURTHOUSE. The Hustings Circuit Courthouse was completed in 1839 on a plot of land in the center of town that fronted Sycamore Street. The building was designed in the Classical Revival style by New York architect Calvin Pollard. The structure's tower may have been added as an afterthought in the architectural plan after it was determined that a bell and clock were needed. The new courthouse contained a courtroom, clerk's office, city offices, and a meeting place for the city council. This postcard is postmarked 1908.

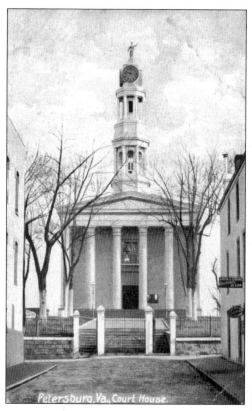

Petersburg, Va., Court House.

COURTHOUSE, PETERSBURG. On June 9, 1864, the courthouse bell rang to summon members of the local militia—those who were too young or too old to enlist in the Confederate army—to meet their units to defend the city against a federal cavalry attack. Fifteen Petersburg men died and 18 were wounded on that day in what is now known as the Battle of Old Men and Young Boys. Three shells struck the courthouse during the siege: one in the roof, one in the tower, and one on the east side of the building. A member of the 1st Michigan Sharpshooters climbed into the tower on the morning of April 3, 1865, to raise his unit's flag over the captured city. The tower's clock was replaced in 1880.

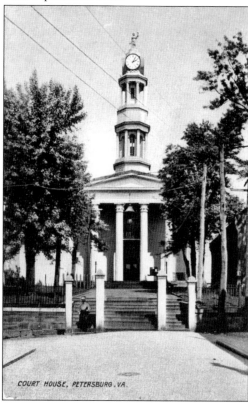

COURT HOUSE, PETERSBURG, VA.

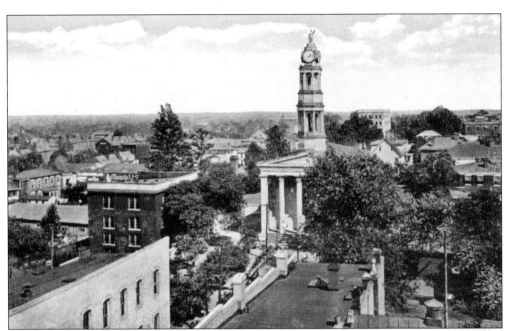

VIEWS OF COURTHOUSE. It is unknown if a statue of Lady Justice was included in the original tower design. However, allegorical sculptures representing justice were popular adornments for civic buildings constructed in the middle to late part of the 19th century. Pictorial and written evidence indicates that a statue was in place atop the tower during the Civil War. The sculpture could have been replaced with a newer version when the clock was replaced in 1880. The statue was removed in 1998 after becoming loose following a storm. An exact replica of the sculpture was cast and placed atop the tower in 2003.

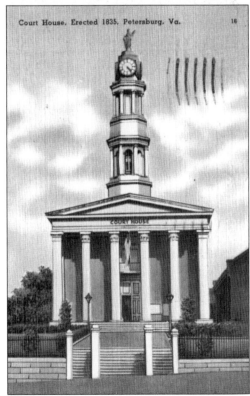

Court House, Erected 1835, Petersburg, Va. 16

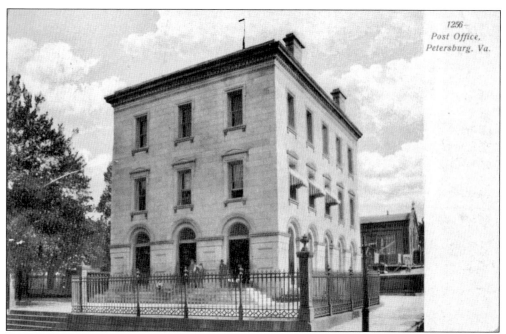

1256—
Post Office,
Petersburg, Va.

CUSTOM HOUSE AND POST OFFICE. This building was constructed by the U.S. government between 1856 and 1858. The granite used for the building was obtained from a quarry in Dinwiddie County. It was originally designed as a two-story structure; a third story was added during construction. The first floor housed the post office, and the second was used by custom officers. The third floor contained additional offices. The iron fence seen in the top postcard was fabricated by the Philadelphia firm of Wood and Perot. The building became a meeting place for Confederate officers during the siege; General Lee and General Beauregard met here on at least one occasion. A Confederate signal station was also located on the roof.

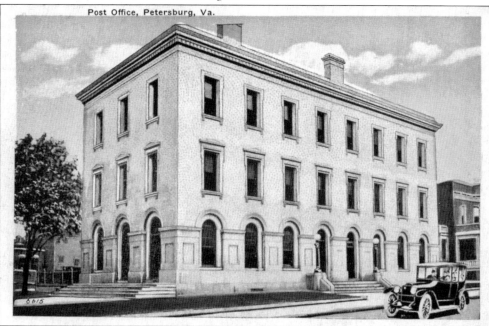

Post Office, Petersburg, Va.

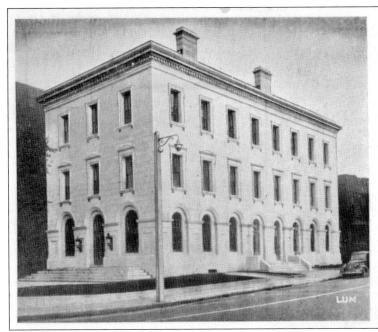

NEW
CITY
HALL

☐

☐

PETERSBURG,
VIRGINIA

CITY HALL. In 1905, an appropriation was requested to build an addition to the Custom House and Post Office. Construction began in 1908. The new addition added 100 feet to the original 60-foot facade. As with the original structure, granite from Dinwiddie County was utilized. The City of Petersburg purchased the building from the federal government in 1941. The top postcard was designed by Petersburg photographer William E. Lum, who used one of his photographs of the building as a basis for the image on the card. The outline of the light post and window details were drawn with pencil onto the original photograph.

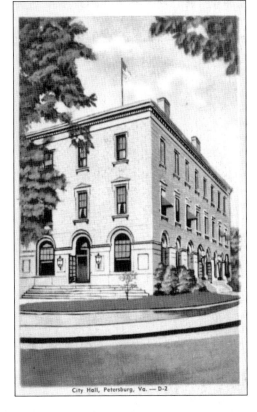

City Hall, Petersburg, Va. — D-2

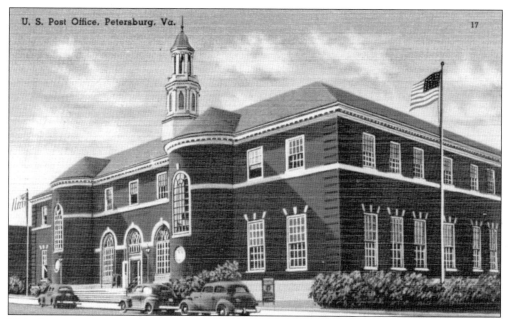

U.S. POST OFFICE, PETERSBURG. The design of the city's new post office on Franklin Street was modeled after the Colonial capitol building in Williamsburg. Constructed in 1935, the interior of the building features two murals executed by artists working for the Depression-era Works Progress Administration.

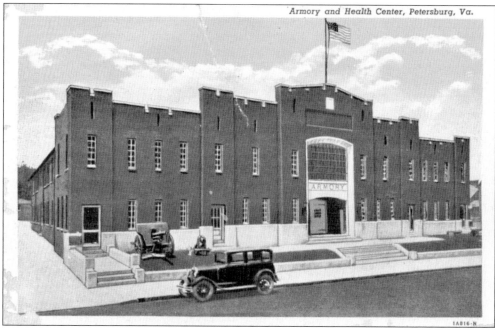

Armory and Health Center, Petersburg, Va.

ARMORY AND HEALTH CENTER. Built in 1925, the Armory and Health Center stood on North Market Street between West Washington and Hinton Streets. A large open space in the center of the building was used for drill purposes and dancing. The first floor contained locker rooms and a kitchen. The health center was located on the second floor and included a laboratory and a waiting room.

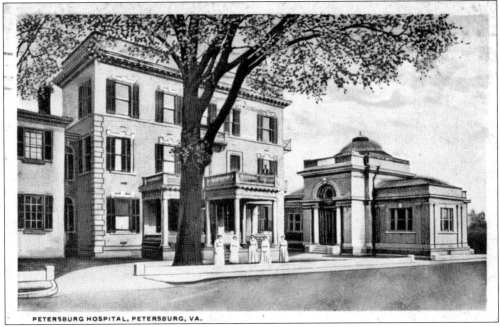

PETERSBURG HOSPITAL, PETERSBURG, VA.

PETERSBURG HOSPITAL. The city's first permanent hospital was located on Bragg's Hill at the intersection of Madison and Washington Streets. Originally known as the Petersburg Home for the Sick, the institution was chartered in 1886. Initially the facility was staffed with women who were members of local churches. Churches would contribute $10 a month to the institution. By the early 20th century, various boards and citizen groups were involved in the administration of the hospital. A residential home for hospital nurses was also located on Madison Street. In 1952, the hospital moved to a new building on Sycamore Street. These buildings were torn down several years later.

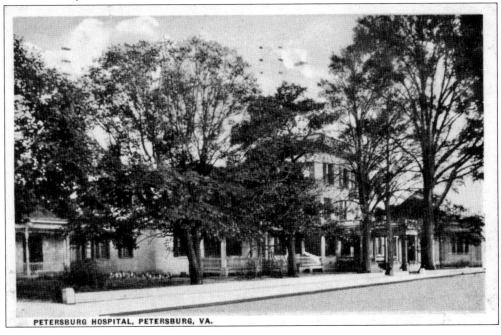

PETERSBURG HOSPITAL, PETERSBURG, VA.

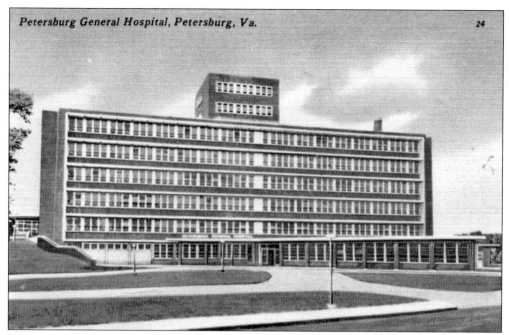

PETERSBURG GENERAL HOSPITAL. Prior to World War II, members of the Petersburg Hospital board procured Mount Erin, the Cameron family estate on South Sycamore Street, for the site of the new hospital. The house was razed in 1942; however, it would be nearly another decade before the dedication of the new hospital. In 1948, the city council appointed a hospital authority to oversee the construction and fund-raising for the new facility. Approximately $1.5 million in private contributions was raised. On June 9, 1951, the cornerstone for the new building was laid. The hospital was dedicated on October 14, 1952.

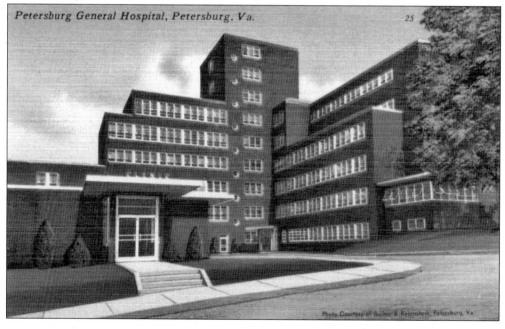

Photo Courtesy of Bucher & Rosenstock, Petersburg, Va.

Seven

BUSINESS AND INDUSTRY

GREETINGS FROM PETERSBURG. The design on the lower right represents three of Petersburg's largest industries in the first half of the 20th century. The eyeglasses symbolize Titmus Optical Company, which was established in 1908. Tobacco continued to be a lucrative business for most of the 20th century. Petersburg was also home to Seward Trunk and Bag Company, at one time the largest luggage manufacturer in the world.

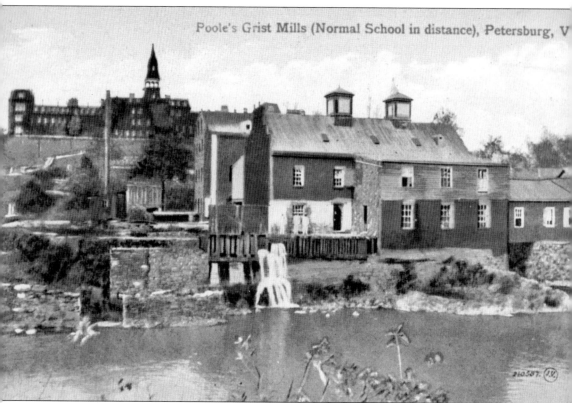

POOLE'S GRIST MILLS. By the close of the 18th century, Petersburg had become a center for the milling industry. Mills were established on the banks of the Appomattox River. On his 1791 visit to the city, George Washington recorded seeing a large quantity of wheat and flour mills near town. By 1835, Petersburg had six flour mills. Corn, flour, and wheat mills continued to serve as important contributors to Petersburg's economy up until the Civil War. By 1914, only two mills were producing flour and grist products. John Poole and his son, William, owned one of the two mills still in operation. Their gristmill complex was located on the Ettrick side of the Appomattox River near Campbell's Bridge. The Pooles ceased operating their mill around 1920. The original Virginia Hall, on the campus of what was then known as the Virginia Normal and Industrial Institute (later Virginia State University), can be seen in the background.

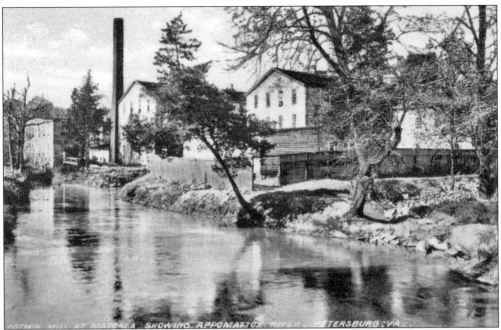

COTTON MILLS. The Matoaca Cotton Mills were built on the north bank of the Appomattox River in 1834. A village for the mill workers was also constructed. During the second quarter of the 19th century, Petersburg became one of the leading cities in Virginia for the manufacture of cotton products. In 1870, there were at least six cotton mills in the city and surrounding area. Together they employed over 500 workers. By 1903, the four remaining cotton mills were under the control of the Virginia Consolidated Milling Company. The Matoaca Mills had 12,000 spindles and 300 looms. Petersburg's cotton industry dwindled in the 1920s due to the drop of cultivation of crops and low profit margins.

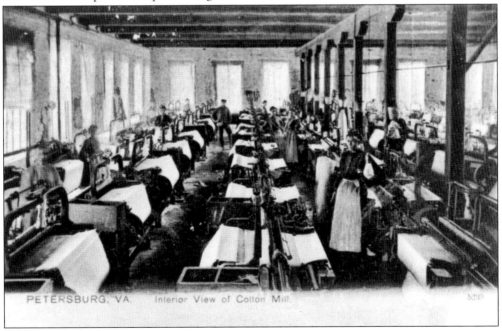

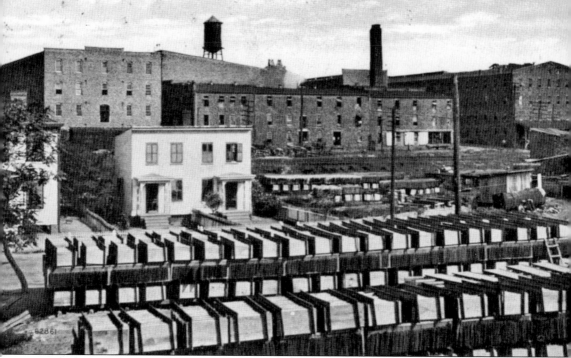

SEWARD'S BAG AND TRUNK FACTORY. Billed as the largest manufacturer of trunks, bags, and cases in the world, the company was founded in 1880 and incorporated as Seward Trunk and Bag Company in 1895. By 1912, the plant consisted of 15 brick buildings extending along High Street and southward, occupying an area of roughly three city blocks. Buildings housed a veneer and slat mill, a blacksmith shop, stables, warehouses, stockrooms, and a shipping department. The tracks of the Seaboard Air Line Railroad passed through the factory; finished goods were loaded on railroad cars and transported all over the world. In the first decade of the 20th century, up to 1,000 workers were employed at the facility. Production averaged 1,000 trunks and 4,000 bags daily. Two power plants with steam engines and an electrical plant were also on site. The company also patented designs on numerous pieces of hardware and luggage accessories including bolts, locks, tray fixtures, and hat supports.

PETERSBURG TRUNK AND BAG COMPANY. This card was sent by the company as an order confirmation to its customers. In the 1920s, the company was located on North Dunlop Street. By 1935, they had consolidated with other manufacturing companies under the name American Hardware Incorporated and were operating out of the Seward factory on High Street.

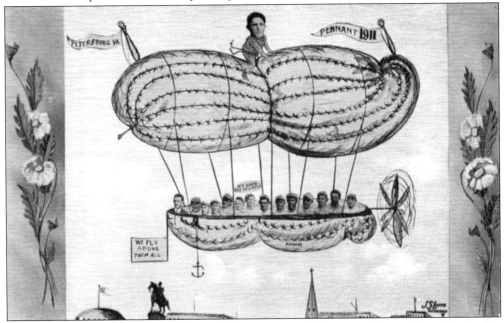

PEANUT FACTORY PENNANT. Although the sponsor of this postcard remains a mystery, the peanut reference relates to one of Petersburg's leading agricultural industries in the early 20th century. Peanuts were listed as the fourth-largest export in 1915 following tobacco, cotton yarns, and luggage. By 1917, there were five peanut factories in Petersburg that cleaned and hulled nuts grown in the surrounding countryside.

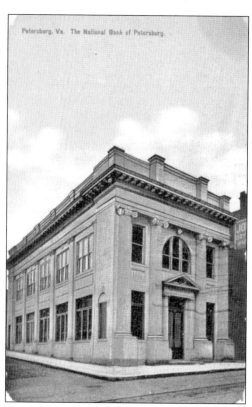

Petersburg, Va. The National Bank of Petersburg.

THE NATIONAL BANK OF PETERSBURG. Organized in 1886, in the early 20th century, the bank advertised as being the oldest national bank in Southside Virginia. Located on the southeast corner of Sycamore and Tabb Streets, the bank boasted of having elegantly furnished and finished banking quarters. The building was also equipped with fire- and burglar-proof safes and vaults.

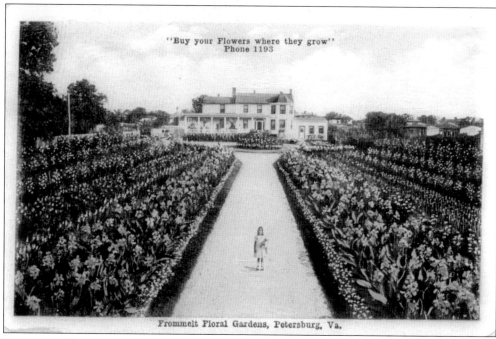

"Buy your Flowers where they grow"
Phone 1193

Frommelt Floral Gardens, Petersburg, Va.

FROMMELT FLORAL GARDENS. This nursery was located at 210 New Street and was in business from around 1918 to 1926. The gardens were owned by Oscar Frommelt and his family. By 1927, Edgar H. Turnes was operating a floral shop at this location.

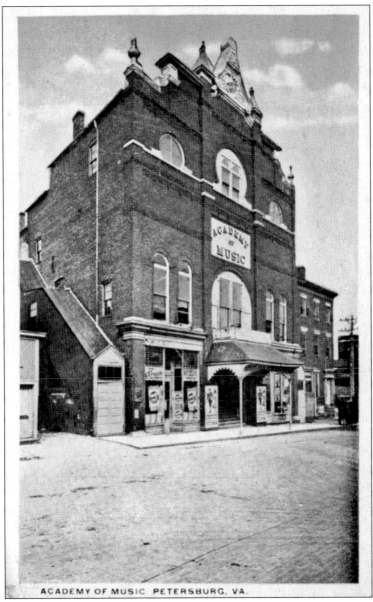

ACADEMY OF MUSIC PETERSBURG, VA.

THE ACADEMY OF MUSIC. Dedicated in October 1871, this building located on Bank Street was acquired by the Petersburg Musical Association in 1886. The Petersburg Musical Association had grown out of the Petersburg Music Club, which had formed in 1868 for study and practice. The association organized festivals with other music societies from around the state and North Carolina. For one week each year, known as "Festival Week," visiting musicians from other member societies would arrive in Petersburg to perform concerts, often conducted by guest conductors. The association provided additional musical entertainment throughout the year during an October-to-May season. Shortly after acquiring the Academy of Music building, the association renovated the structure. The newly remodeled auditorium could seat between 1,400 and 1,500 people and could accommodate up to 400 performers. The association sold the building in 1896, although the theater continued to host vaudeville acts during the first two decades of the 20th century. The building was demolished in 1930.

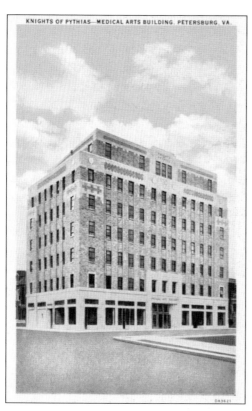

MEDICAL ARTS BUILDING. Constructed in 1930, the building originally housed the local chapter of the Knights of Pythias on the seventh floor along with the Pythian Sisters Hall several floors below. The Knights of Pythias are a fraternal order dedicated to the cause of world peace; the Pythian Sisters are an auxiliary group of the Knights. Other early tenants included physicians, insurance and loan companies, dentists, an architect, and the WPHR radio station. A restaurant named the Chaya Tea Room was also located on the seventh floor.

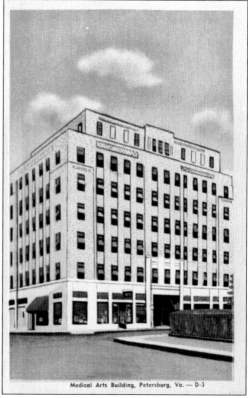

Medical Arts Building, Petersburg, Va. — D-3

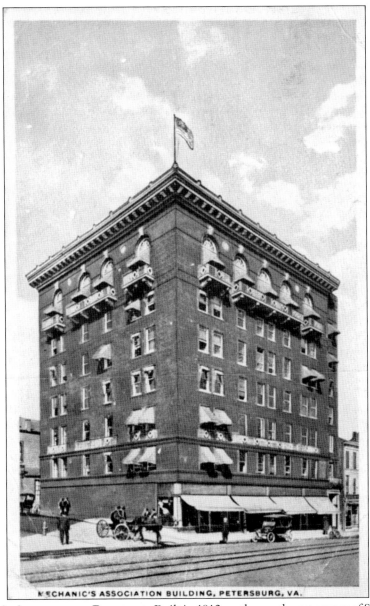

MECHANIC'S ASSOCIATION BUILDING, PETERSBURG, VA.

MECHANIC'S ASSOCIATION BUILDING. Built in 1912 on the northwest corner of Sycamore and Tabb Streets, the Mechanic's Association Building replaced the former Mechanic's Hall constructed on the site in 1839 by the Petersburg Benevolent Mechanic's Association. The association's mission was to promote the mechanical arts and sciences and engage in benevolent and charitable activities. They conducted day and evening classes and provided financial aid to members and their widows. The association's original building consisted of a banquet hall, museum, and library. During the Siege of Petersburg, Mechanic's Hall hosted amateur entertainment and musical performances. Original tenants in the new building included the chamber of commerce, Chesterfield Land Corporation, insurance and investment companies, and offices of the Seaboard Air Line Railroad. The Petersburg Benevolent Mechanic's Association dissolved in 1922. By 1924, the building was used as offices for the mayor, city attorney, and other city officials. Various retail establishments and the Dinwiddie and Petersburg telephone companies were also tenants.

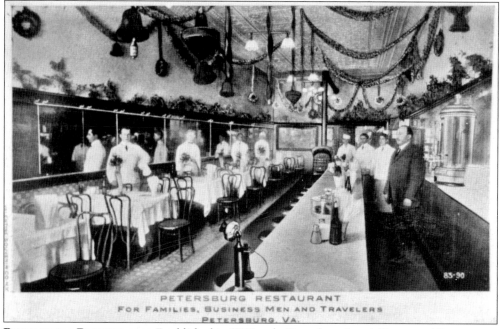

PETERSBURG RESTAURANT. Established in 1907 as the Petersburg Lunch Room and Restaurant, by 1912, the restaurant was billed as one of the most popular dining rooms in the city. In addition to tables, a counter was provided for individuals who wanted a light lunch. The business advertised as being open day and night and serving hot meals at all hours.

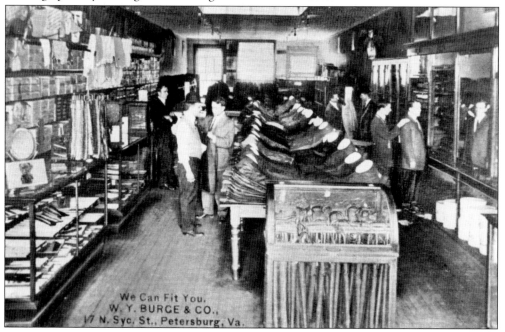

W. Y. BURGE AND COMPANY. The clothier and men's furnishings store operated on Sycamore Street as early as 1903. The shop was originally known as Burge and Woody Clothiers. By 1909, W. Y. Burge was the sole owner of the establishment. Umbrellas are displayed in a unique case in the foreground of the postcard.

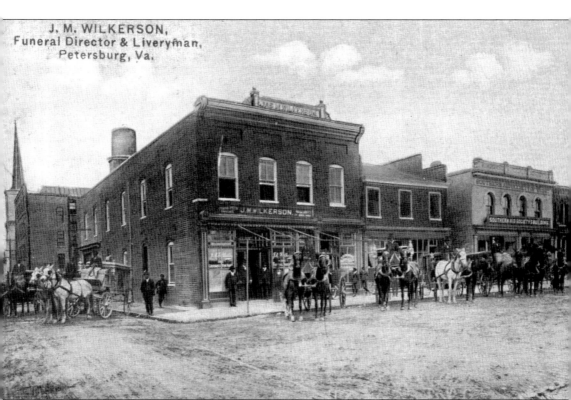

J. M. WILKERSON,
Funeral Director & Liveryman,
Petersburg, Va.

WILKERSON'S FUNERAL HOME. Located on South Avenue in the neighborhood known as the Triangle, Wilkerson's Funeral Home has been in operation since 1874. J. M. Wilkerson was a carpenter who was often called upon to build coffins. He opened J. M. Wilkerson Undertaking Company on Harrison Street in 1874. His sons, J. M. Wilkerson II and Samuel, inherited the business after their father's death. J. M. Wilkerson II became the first licensed African American embalmer in Virginia. The brothers moved the business to South Avenue. In 1912, their building was described as containing offices, embalming rooms, and a showroom equipped with dust-proof cabinets that housed caskets and burial suits and gowns. Wilkerson also owned a livery stable on College Place that housed up to 20 horses. A carriage house adjacent to the stable contained a variety of vehicles. Carriages and horses were made available to mourners and friends. The building next door to Wilkerson's housed a branch of the Southern Aid Society, one of the oldest African American insurance companies in the United States. (Postcard courtesy of Russell W. Davis.)

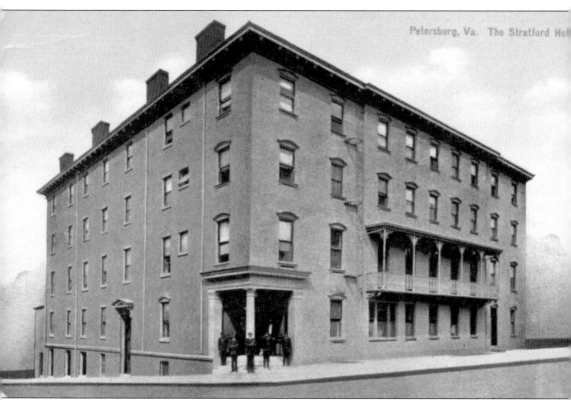

THE STRATFORD HOTEL. Originally known as the Bollingbrook Hotel, this building was completed in 1828 and was located on the northeast corner of Bollingbrook and Second Streets. A fourth story was added to the structure in 1857. During the Civil War, Confederate officers frequently roomed at the hotel. In 1906, the building again underwent renovations to modernize the facility and the name was changed to the Stratford Hotel. The hotel contained 60 rooms. An office, writing room, and sitting room fitted with leather easy chairs were located on the first floor. The hotel also featured a spacious dining room and bar stocked with imported and domestic wines, liquors, and cigars. The entire building was heated by steam and lighted by electricity. An advertisement for the hotel also boasted of ample bath facilities. The business closed in the 1920s, most likely due to competition from the larger Hotel Petersburg. The building was demolished in 1932.

HOTEL PETERSBURG. In a 1914 chamber of commerce report, it was noted that there was an active movement by local businesses to construct a modern hotel in Petersburg. The chamber felt that a large hotel would make the city more marketable and would bring more visitors in. The Citizens Hotel Company organized and purchased property on West Tabb Street for this purpose. Constructed in 1915, the Hotel Petersburg had the unique distinction of being built completely of fireproof materials. The hotel contained 118 rooms and spacious dining facilities complete with banquet rooms. Many civic organizations, businesses, and local companies hosted banquets in the hotel. Weddings and wedding receptions were also held in the facility. The hotel remained in operation for over 50 years.

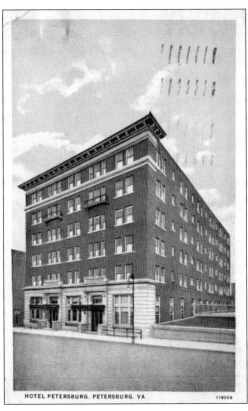

HOTEL PETERSBURG. PETERSBURG. VA.

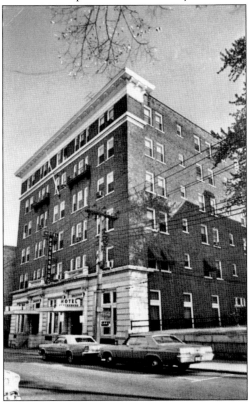

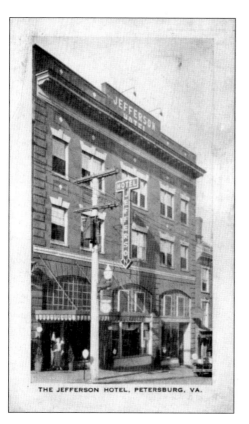

THE JEFFERSON HOTEL, PETERSBURG, VA.

THE JEFFERSON HOTEL, PETERSBURG.
This hotel opened in 1915 on Sycamore Street near Old Street. The hotel contained 70 guest rooms and 30 baths. One of the early hotels to cater to automobile travelers, this establishment provided free covered parking to its guests. The Jefferson Barber Shop was also located in the hotel.

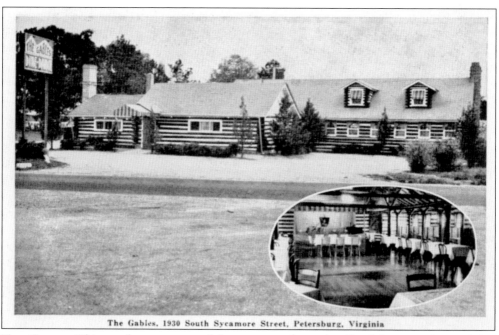

The Gables, 1930 South Sycamore Street, Petersburg, Virginia

THE GABLES. This popular restaurant and dance spot was located on South Sycamore Street. A fire destroyed the establishment in the mid-1950s, and the building was demolished shortly after.

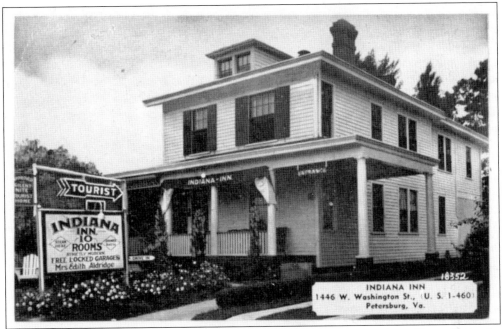

INDIANA INN
1446 W. Washington St., (U. S. 1-460)
Petersburg, Va.

INDIANA INN. Located on West Washington Street on the western edge of Petersburg, the Indiana Inn catered to tourists driving on Routes 1 and 460. The 10-room inn advertised having steam heat, innerspring beds, and free locked garages for guests to park their cars.

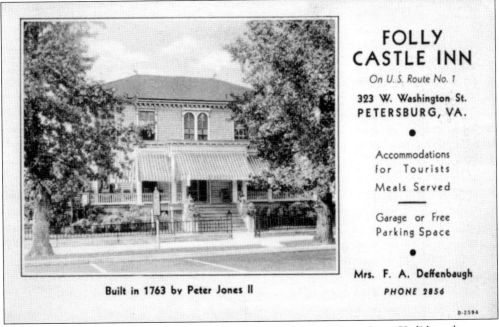

Built in 1763 by Peter Jones II

FOLLY CASTLE INN

On U. S. Route No. 1

323 W. Washington St.
PETERSBURG, VA.

•

Accommodations
for Tourists
Meals Served

Garage or Free
Parking Space

•

Mrs. F. A. Deffenbaugh

PHONE 2856

FOLLY CASTLE INN. Built in 1763, the home's original owner, Peter Jones V, did not have any children at the time he built the spacious house, so the structure earned the nickname Folly Castle as a tribute to his "folly." During the second quarter of the 20th century, the house was converted into an inn complete with a restaurant that was also a popular gathering place for locals.

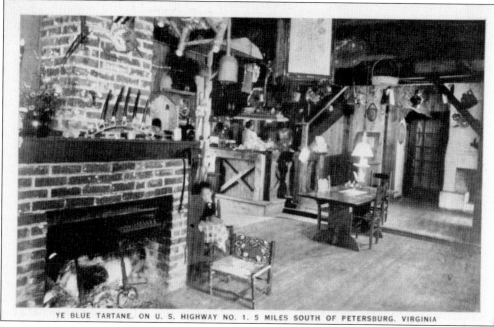

YE BLUE TARTANE. ON U. S. HIGHWAY NO. 1, 5 MILES SOUTH OF PETERSBURG, VIRGINIA

YE BLUE TARTANE. This motor court located on Route 1 five miles south of Petersburg included brick cabins as well as motel rooms. A craft shop and a Shell service station were also on-site. During the second quarter of the 20th century, many motels sprang up on Route 1 south and north of the city.

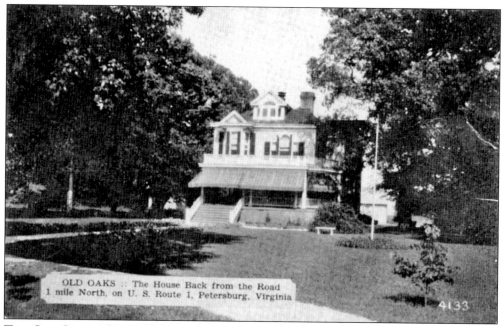

OLD OAKS :: The House Back from the Road
1 mile North, on U. S. Route 1, Petersburg, Virginia

4133

THE OLD OAKS. This establishment was another large house that was converted into an inn to cater to Route 1 traffic. The inn was located one mile north of Petersburg and 20 miles south of Richmond. The description on the reverse of the card states that the inn had private baths, hot water, locked garages, and home-cooked foods.

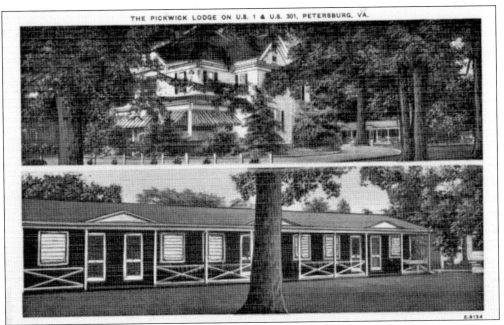

THE PICKWICK LODGE ON U.S. 1 & U.S. 301, PETERSBURG, VA.

THE PICKWICK LODGE. This motor lodge was recommended by Duncan Hines, who published a series of guidebooks in the second quarter of the 20th century. In the 1950s, Hines's name would be placed on a line of grocery products, including cake mixes. The lodge featured motel rooms behind the main building.

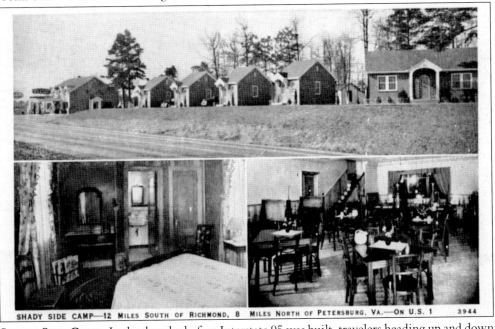

SHADY SIDE CAMP—12 MILES SOUTH OF RICHMOND, 8 MILES NORTH OF PETERSBURG, VA.—ON U.S. 1 3944

SHADY SIDE CAMP. In the decades before Interstate 95 was built, travelers heading up and down the East Coast would use U.S. 1 as their main route. By the mid-1950s, Route 1 had become the most heavily traveled through road in Virginia and one of the busiest highways in the country. Many motels and other businesses catering to travelers sprang up along the corridor between Richmond and Petersburg.

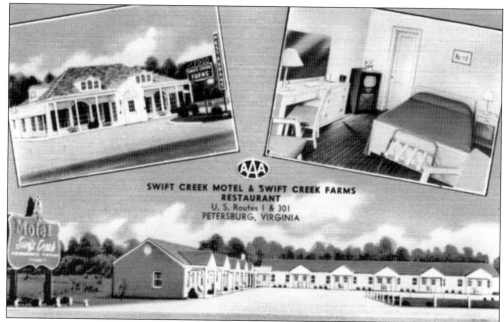

SWIFT CREEK MOTEL. Built in 1953, the motel and restaurant prominently advertised that it was recommended by both Duncan Hines and the American Automobile Association. Modern conveniences included air conditioning, televisions, and tile baths and showers. Their motto was "Quality Made Us Famous." The sender of this card, postmarked 1954, writes, "Arrived here at 8:30, had ice cream and cake, ready for bed now, drove 166 miles."

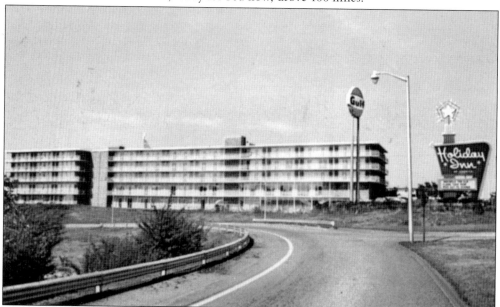

HOLIDAY INN. In the 1960s, businesses catering to interstate traffic sprang up along Interstate 95. The Holiday Inn and the neighboring Gulf gas station were two of the establishments that opened on the busy interchange of Interstate 95 and Washington Street. The caption on the reverse of the card boasts that the hotel was conveniently located near Fort Lee, the Hopewell Industrial Center, and Petersburg Battlefield Tours.

Eight

FORT LEE

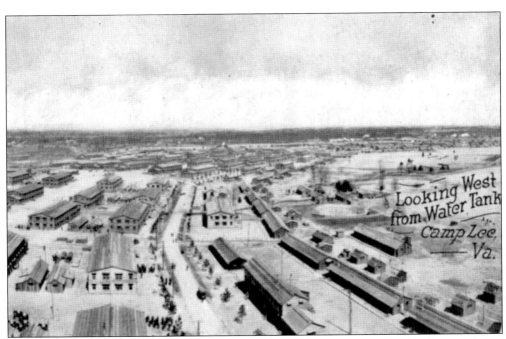

LOOKING WEST FROM THE WATER TANK, CAMP LEE. In June 1917, shortly after the United States entered World War I, ground was broken two miles outside of Petersburg for buildings that would become part of the newly established national army cantonment known as Camp Lee. Troops were housed in quarters at Camp Lee and participated in training and drilling exercises before they were sent off to fight in Europe.

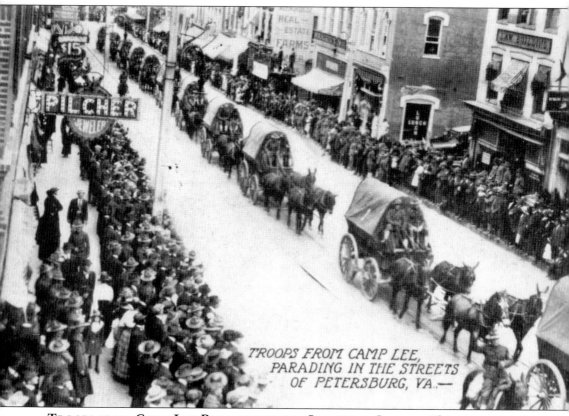

TROOPS FROM CAMP LEE, PARADING IN THE STREETS OF PETERSBURG, VA.—

TROOPS FROM CAMP LEE PARADING DOWN SYCAMORE STREET. This view was taken from the corner of West Tabb and Sycamore Streets. The Pilcher's jewelry store sign can be seen hanging from the Mechanic's Association building in the left foreground. The crowds of spectators on the sidewalk, some lined up five deep, demonstrate the citizens of Petersburg's patriotism for the war effort. The residents of Petersburg were eager to entertain and provide aid to the troops stationed at Camp Lee. Members of local churches, fraternal organizations, women's clubs, and other community groups performed a variety of services that contributed to the well-being of the soldiers. Activities included raising money, knitting clothing, making bandages, and hosting receptions for camp personnel. Clubs were formed to host chaperoned dances for the troops and local ladies. Space and supplies were also provided for other services and forms of entertainment, such as letter writing and games.

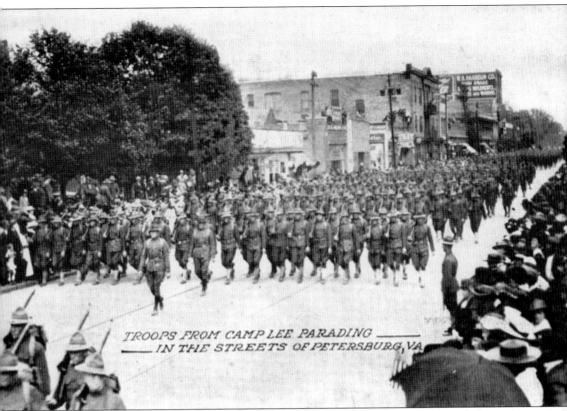

TROOPS FROM CAMP LEE PARADING
IN THE STREETS OF PETERSBURG, VA

TROOPS FROM CAMP LEE PARADING DOWN WEST WASHINGTON STREET. The painted building sign for the W. H. Harrison Company, a dealer in agricultural implements, seeds, and hardware, can be seen in the background of this scene on West Washington Street. Spectators were lined up on either side of the street to review the line of Camp Lee troops marching past. The citizens of Petersburg were involved in various national causes that supported war efforts. Food and fuel conservation programs were introduced. Support for the programs resulted in "Heatless Mondays," "Lightless Thursdays and Sunday nights," and restricted use of automobiles on Sundays. War gardens were also planted. Liberty Loan Bond drives were also held. Petersburg residents easily surpassed the subscription goal. Eighty-four men from Petersburg lost their lives in World War I before Petersburg welcomed home its local servicemen in May and June 1919.

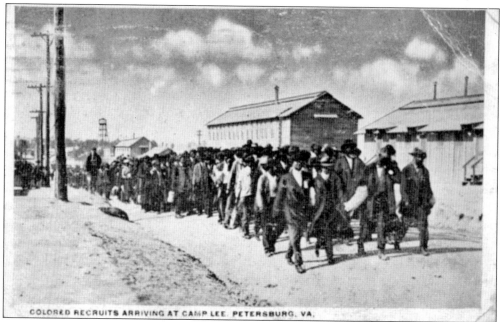

COLORED RECRUITS ARRIVING AT CAMP LEE, PETERSBURG, VA.

BLACK TROOPS ARRIVING AT CAMP LEE. This postcard, postmarked 1918, depicts a line of African American troops arriving at Camp Lee for military service. The soldiers trained and served in segregated units. The African American troops stationed at Camp Lee represented a fraction of the 400,000 African American soldiers who served in World War I.

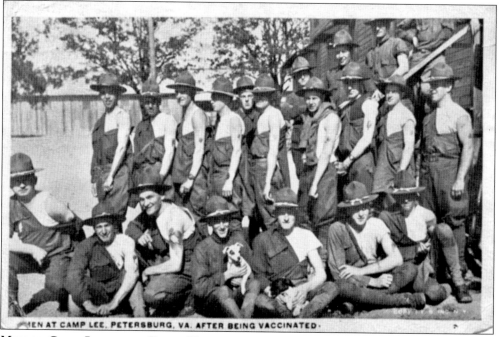

MEN AT CAMP LEE, PETERSBURG, VA. AFTER BEING VACCINATED.

MEN AT CAMP LEE AFTER BEING VACCINATED. In 1911, the army mandated that all soldiers entering service be vaccinated for typhoid. This postcard, printed around 1918, shows recently vaccinated troops. In that same year, the influenza pandemic reached Petersburg and Camp Lee. Over 500 troops and 140 Petersburg residents died from the pandemic.

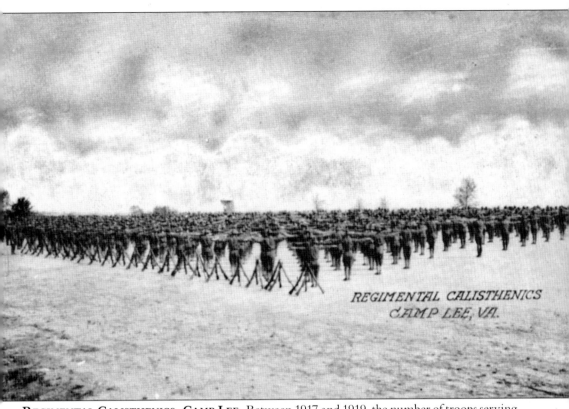

REGIMENTAL CALISTHENICS
CAMP LEE, VA.

REGIMENTAL CALISTHENICS, CAMP LEE. Between 1917 and 1919, the number of troops serving at Camp Lee reached over 60,000. Camp Lee's population was third in the state of Virginia behind Richmond and Norfolk. The first troops to arrive at Camp Lee were members of the 80th Division. They arrived at the camp in August 1917. The division was made up of soldiers from Pennsylvania, Virginia, and West Virginia. A little over 50 years earlier, the states were at war with each other, with Civil War battles fought on and near land that was now Camp Lee. The 80th Division left Camp Lee in May 1918 for service in France. The 37th Division arrived for training shortly afterwards. In addition to calisthenics, troops participated in marching and drilling exercises and received training on how to operate machine guns and other weapons and in trench warfare.

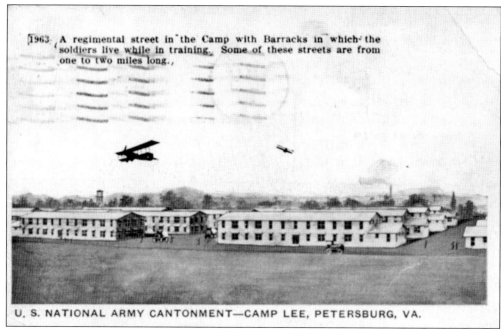

1963. A regimental street in the Camp with Barracks in which the soldiers live while in training. Some of these streets are from one to two miles long.,

U. S. NATIONAL ARMY CANTONMENT—CAMP LEE, PETERSBURG, VA.

A REGIMENTAL STREET SHOWING BARRACKS, CAMP LEE. Soldiers were housed in standard army-designed barracks that could each house 200 recruits. From June 1917 to September 1917, more than 1,500 buildings were built. Other types of buildings constructed included a hospital, three fire stations, and various other service facilities.

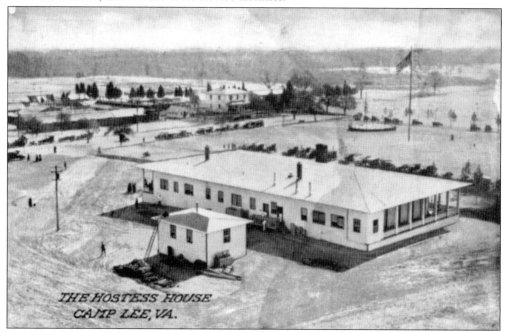

THE HOSTESS HOUSE
CAMP LEE, VA.

THE HOSTESS HOUSE, CAMP LEE. Staffed by local members of the YWCA, the Hostess House provided the troops with a place to meet visiting relatives and friends. The house also provided many amenities for soldiers, including letter-writing rooms, a magazine library, musical instruments to play, and a cafeteria.

YMCA BUILDING, CAMP LEE. The YMCA had a strong presence at Camp Lee. Activities for troops were held at several YMCA venues on practically a daily basis. Movies were shown and boxing events were staged in an auditorium built by the YMCA at the camp. The entertainment was provided free of charge for troops.

REGIMENTAL BAND, CAMP LEE. Each regiment stationed at Camp Lee had its own band. Music was an important part of both troop parades and reviews. The bands also provided entertainment for both soldiers and local citizens. A proliferation of patriotic music was published during World War I, including pieces dedicated to the boys of Camp Lee.

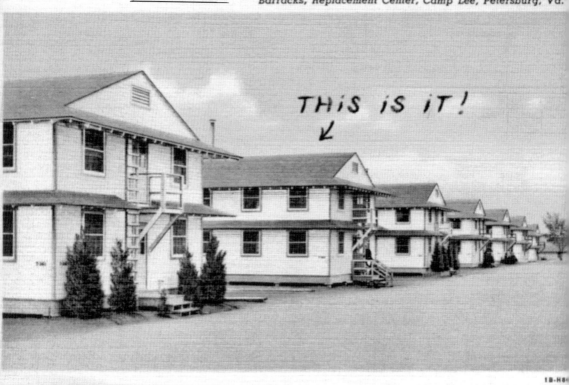

BARRACKS REPLACEMENT CENTER, CAMP LEE. After World War I ended in 1919, Camp Lee was closed. The majority of the property was used to create a game preserve. However, with the start of World War II and the remobilization of troops, Camp Lee emerged again, this time as the site of the Quartermaster Corps Replacement Training Center. In February 1941, a new quartermaster center was activated at the camp, and in October 1941, the army moved the Quartermaster School to Camp Lee. The Quartermaster Corps, a division of the army, provides an astounding array of services and supplies to troops in combat. New recruits who reported to Camp Lee received basic military training in addition to specialized training in skills as diverse as typing, film production, graphic arts, and material handling. More than 300,000 quartermaster officers and soldiers trained at Camp Lee during World War II.

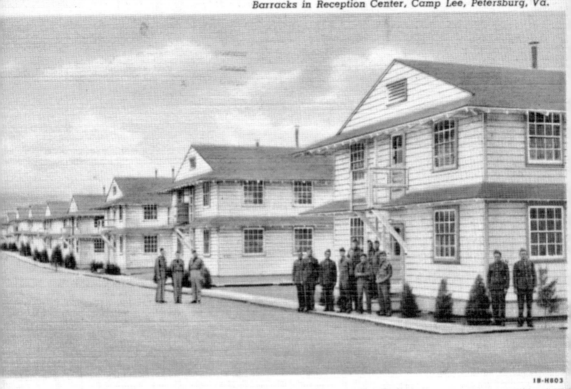

IB-H803

BARRACKS IN RECEPTION CENTER, CAMP LEE. The second Camp Lee closely followed the layout of the original camp. The camp was designed in a U-shaped pattern that extended approximately four miles from tip to tip. After orders were given for construction in October 1940, hundreds of workers descended on the camp to build a variety of structures including barracks, classrooms, chapels, medical facilities, mess halls, and recreation halls. Other training facilities built at the camp included a rifle range, obstacle courses, a simulated train line, and a miniature model theater of operations. The new barracks each housed 63 men. Although the barracks did contain indoor showers and sinks, the sparse interiors contained unpainted walls and exposed studs. Soldiers hung their clothing from the rafters. The camp contained many services that are normally found in medium-sized cities. These included a bakery, commissary, several movie theaters, and a military police detachment to provide law enforcement and security.

SERVICE CLUB FOR ENLISTED MEN, CAMP LEE. Like their World War I counterparts, soldiers stationed at Camp Lee during World War II were provided with ample recreational and social opportunities. Athletic teams and leagues were formed to boost the morale of soldiers. Service clubs, recreation halls, and movie theaters provided entertainment venues for the troops. Several USO clubs were also established in Petersburg. This postcard was published by Petersburg photographer William Lum and is postmarked 1942. It was sent from a private who was stationed at Camp Lee to a woman in Blacksburg. The soldier simply writes, "Here's the card I promised, will send more later." After World War II ended, Camp Lee remained open as a quartermaster training center. The camp also became home to the Women's Army Corps Training Center from 1948 until 1954. In 1950, the U.S. Army ruled to permanently retain the post and its name was changed to Fort Lee. Today more than 25,000 quartermasters are trained at Fort Lee each year.

Nine

TRANSPORTATION

FERRY CONNECTING PETERSBURG WITH MATOACA. This passenger ferry boat was operated by Jim Seay, a local boatman. Beginning in 1902, before construction of the Route 600 bridge, he carried passengers between Matoaca and Ferndale Park in his modified batteau, charging 5¢ round-trip. A batteau is a narrow, relatively flat-bottomed boat. The vessels were originally used to ship hogsheads of tobacco on the Appomattox River.

RIVER AT FERNDALE PARK FERRY. Ferndale Park was a popular amusement park in the first quarter of the 20th century. Mill workers from Matoaca would use the ferry to get to the park. An electric trolley line ran from Petersburg to the park. The park featured a merry-go-round, ice-cream parlor, bowling alley, and a movie theater designed especially for the screening of silent films.

POWER DAM ON THE APPOMATTOX. In 1795, the Upper Appomattox Company was incorporated to provide improvements to make the Appomattox River more navigable. By 1810, a five-mile-long canal had been completed so that vessels could bypass the falls on their way into Petersburg. When travel on the canal ceased in 1902, the canal was widened and its water power used to generate electricity for a power station.

POCAHONTAS BRIDGE. The first bridge to cross over the Appomattox River to the settlement named Pocahontas was built in 1752. During the Revolutionary War battle of Petersburg on April 25, 1781, troops from the Virginia militia retreated over the bridge from advancing British troops. The militia destroyed the bridge to prevent the British from crossing. Confederate soldiers retreated across the bridge in April 1865 and were ordered to burn the bridge following their retreat. A 16-year-old soldier was killed by federal troops while he was setting fire to the bridge. The bridge shown in these postcards was built after the Civil War. The top postcard was printed in 1906; at that time, the Pocahontas Basin was located at the foot of the bridge. In 1925, a new Appomattox River Bridge replaced the Pocahontas Bridge.

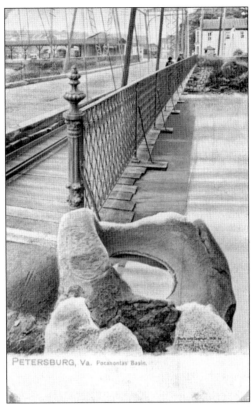

PETERSBURG, Va. Pocahontas Basin.

POCAHONTAS BRIDGE. PETERSBURG. VA.

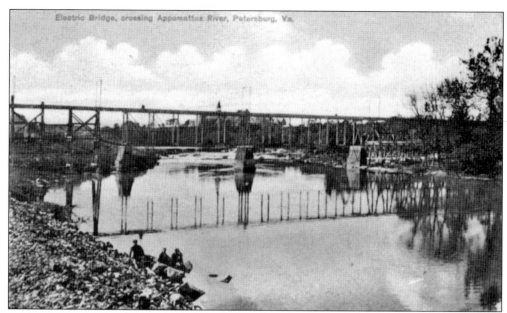

ELECTRIC BRIDGE CROSSING APPOMATTOX. The Richmond and Petersburg Electric Railway opened in 1902 and provided an electric car line between the two cities. The 1-hour-15-minute trip took passengers to the Manchester station south of Richmond, where they changed cars for downtown Richmond. The increased availability of automobiles drove the company out of business after years of service.

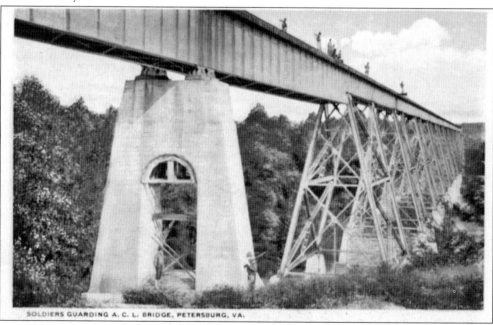

ATLANTIC COAST LINE RAILROAD BRIDGE. The Atlantic Coast Line Railroad was one of two railroads that ran north and south through the city. The segment between Petersburg and Weldon, North Carolina, originally known as the Petersburg Railroad, was built in the 1830s to bring tobacco up from North Carolina. The circumstances surrounding the soldiers guarding the bridge are unknown.

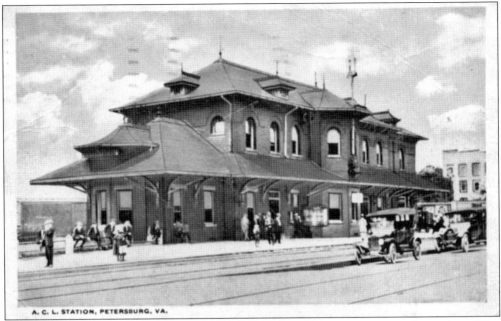

A. C. L. STATION, PETERSBURG, VA.

ATLANTIC COAST LINE RAILROAD DEPOT. This passenger station was located on West Washington Street near Union Street. In 1898, the Petersburg Railroad was purchased by the Petersburg and Richmond Railroad; the merged railroad was called the Atlantic Coast Line Railroad of Virginia. By 1900, other railroad mergers had stretched the system from Richmond to Augusta, Georgia. In 1902, the railroad system was extended into Florida. This brick passenger station was built in the late 19th century. A block-long freight depot was located to the east of the station and extended to Sycamore Street. The railroad also established a freight beltline along the western edge of Petersburg. By the mid-20th century, both passenger and freight trains were using this beltline, eliminating the need for trains to travel into the city. (Bottom postcard courtesy of Russell W. Davis.)

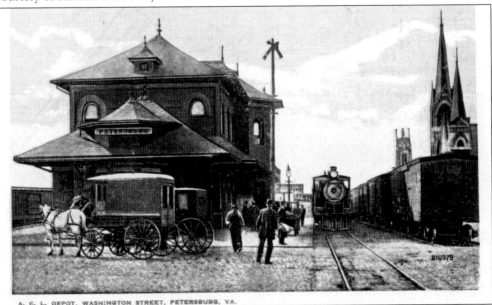

A. C. L. DEPOT, WASHINGTON STREET, PETERSBURG, VA.

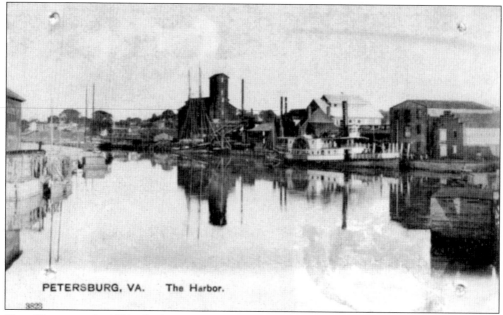

PETERSBURG, VA. The Harbor.

THE HARBOR. In 1850, the Lower Appomattox River channel was turned over to the City of Petersburg. The city had plans to construct a proper ship channel 17 feet deep and 600 feet wide. The project was abandoned, but the channel was deepened by 10 to 12 feet. However, silt building up in the channel was a problem and continues to be a problem today. During the last quarter of the 19th century, plans were underway to route the Appomattox River away from Petersburg's harbor and surrounding buildings to protect the area from flood damage. This plan came to fruition in 1909, when a new two-mile cut known as the Diversion Channel was created. Pocahontas Island was created by the Diversion Channel—the island had previously been land on the north side of the river.

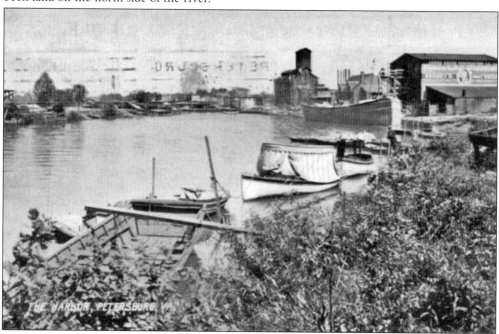

THE HARBOR, PETERSBURG, VA.

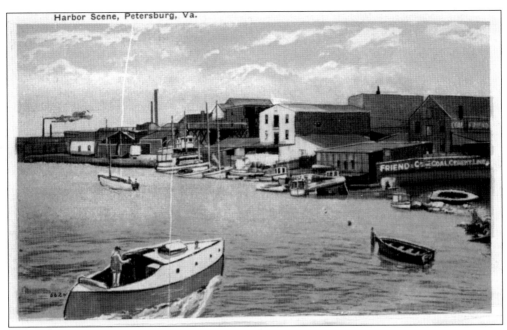

VIEWS OF THE HARBOR. During the first half of the 19th century, ships were leaving Petersburg ports for foreign destinations. However, after the Civil War, larger ports in Richmond and Norfolk absorbed much of the international freight traffic. By 1917, the majority of the water freight bound for Petersburg was arriving at City Point and being shipped by railroad into Petersburg. The demand for passenger steamboat travel was still high in 1917. The Furman Line and Merchants Line were operating daily round-trip steamboat services between Petersburg and Richmond. Gradually railroads and automobiles made boat travel unprofitable. This is made evident by the construction of Union Station adjacent to Petersburg's harbor. The station is visible in the background of the bottom postcard.

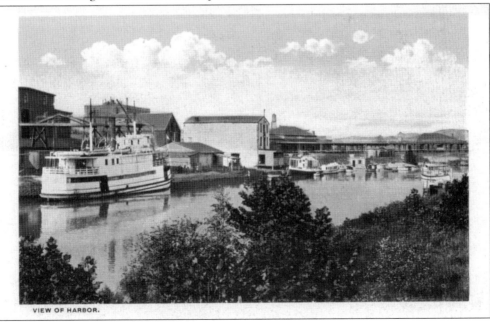

VIEW OF HARBOR.

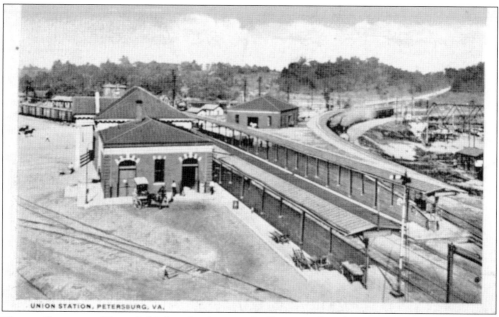

UNION STATION, PETERSBURG, VA.

UNION STATION. Though Union Station was built as a railroad station for the Norfolk and Western Railway in 1909, the railroad's origins in Petersburg were two earlier routes. In 1849, the South Side Railroad began building westward, reaching Lynchburg in 1854. In 1853, under the supervision of Chief Engineer William Mahone, the Norfolk and Petersburg Railroad began construction. The line was completed in 1858. During the Civil War, Mahone would earn the rank of major general for commanding his Confederate troops during the Battle of the Crater. After the war, Mahone was elected president of three railroads, including the South Side and the Norfolk and Petersburg; these were all consolidated into one company. In 1881, the railroad was sold to a Philadelphia company and the name was changed to the Norfolk and Western.

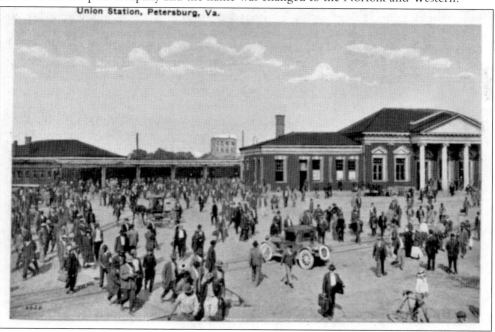

Union Station, Petersburg, Va.

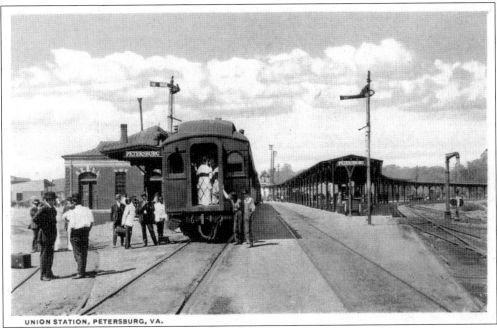

UNION STATION, PETERSBURG, VA.

UNION STATION. By 1886, the Norfolk and Western Railroad built a brick passenger station in Petersburg. This station was heavily damaged during a flood in 1908. In 1909, construction started on the new station along with improvements to the tracks and grounds. The building was completed in 1910. Passengers arriving at Union Station could catch trains bound towards Chattanooga, Memphis, Nashville, Atlanta, and New Orleans. A newspaper dealer and restaurant called the Union News Company operated out of the station in its early years. The restaurant changed names several times throughout the station's existence. The last train to utilize the station pulled out on May 1, 1971. (Postcards courtesy of Russell W. Davis.)

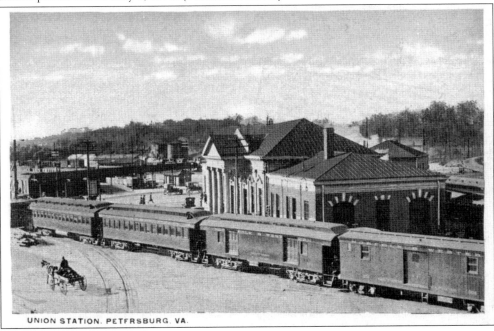

UNION STATION. PETFRSBURG. VA.

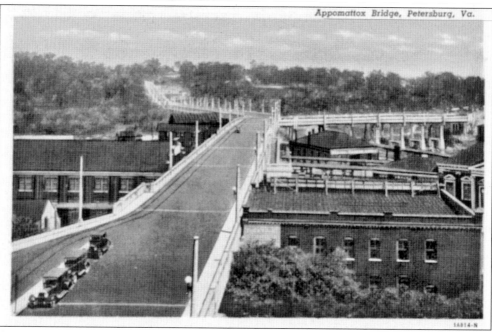

APPOMATTOX RIVER BRIDGE. Construction began on the bridge seen in these postcards in 1924. The newly completed bridge was dedicated on October 29, 1925. The dedication ceremony featured an inspection of the bridge by invited guests along with an evening banquet at the Hotel Petersburg. The bridge replaced the Pocahontas Bridge, which had been the primary point of the Appomattox River crossing into Petersburg since 1752. A ramp from the new bridge connected to Pocahontas Island. In 1992, the bridge was renamed in honor of Dr. Martin Luther King Jr. A new bridge was constructed to replace this one between 2001 and 2003. Dedicated on October 30, 2003, the new bridge was also named in Dr. King's honor. (Bottom postcard courtesy of Russell W. Davis.)

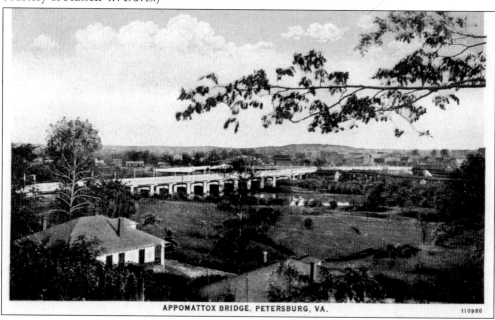
APPOMATTOX BRIDGE, PETERSBURG, VA.

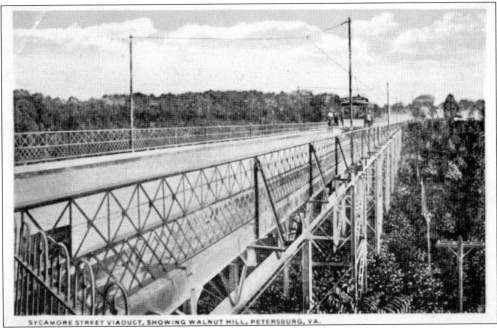

SYCAMORE STREET VIADUCT, SHOWING WALNUT HILL, PETERSBURG, VA.

SYCAMORE STREET VIADUCT. This viaduct carried a road and streetcar line to the Walnut Hill neighborhood. The span extended from Sycamore Street. In 1921, Walnut Hill was annexed into Petersburg and experienced growth as a residential neighborhood. The top postcard shows an electric trolley crossing the viaduct. However, the electric trolley service was short-lived; trackless trolley cars designed as electric buses replaced the electric trolley cars as early as 1923. These early buses were frequently plagued with mechanical difficulties and were replaced in 1927 by the first gas buses to appear in Petersburg. The viaduct bridge was replaced with a vehicular bridge, and the ravine underneath became the roadbed for Interstate 85.

VIEW FROM VIADUCT, WALNUT HILL, PETERSBURG, VA.

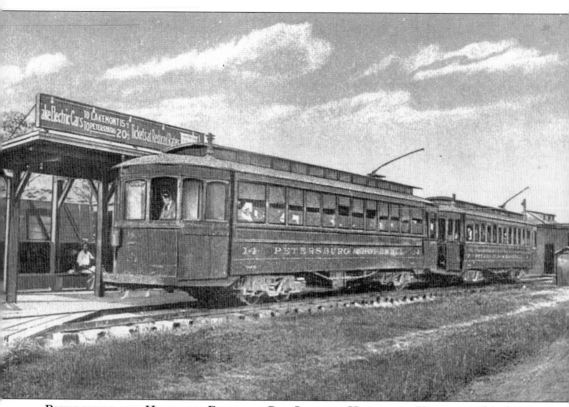

PETERSBURG AND HOPEWELL ELECTRIC CAR STATION, HOPEWELL, VIRGINIA. This electric car line was established around 1917 and flourished during the World War I years as a result of the burgeoning soldier population at Camp Lee. The tracks entered Petersburg along Wythe Street and ended at a station located near the intersection of Sycamore and Wythe Streets. The closure of Camp Lee after World War I led to a significantly decreased number of passengers on this interurban line. However, the trolley service managed to remain in business until 1939. In 1940, a bus line between Petersburg, Camp Lee, and Hopewell began operation. During World War II, as a result of the reestablishment of Camp Lee, five separate companies operated buses between Petersburg, Camp Lee, and Hopewell. After 1945, three transit companies continued to operate buses between the two cities; in 1956, the Petersburg-Hopewell Bus Lines assumed responsibility. The company operated as the Tri-City Coaches until the mid-1970s. (Postcard courtesy of Russell W. Davis.)

Ten

NEIGHBORS, NEIGHBORHOODS, AND NEIGHBORING COMMUNITIES

CORLING STREET, LOOKING EAST, PETERSBURG, VA.

CORLING STREET LOOKING EAST. The caption on the back of this card states that this street is located in "one of the beautiful residential sections of this fast growing City." Corling Street is located off of South Sycamore Street on the edge of the Ravenscroft neighborhood. From around 1880 to about 1930, many Colonial Revival–style residences such as these sprung up in neighborhoods throughout the city.

WASHINGTON AND DAVIS STREETS LOOKING WEST. Among the residential neighborhoods that developed in the 19th century were those along East and West Washington Streets. Located west of Market Street, Davis Street extends down to High Street, one of the oldest residential streets in Petersburg. The first street railway on Washington Street consisted of horse-drawn cars and began service in 1883.

FRANKLIN AND ADAMS STREETS. Due to the close proximity to Sycamore Street and the courthouse, the streets around the intersection of Franklin and Adams Streets offered convenient residential locations during the 19th century. However, as downtown Petersburg grew, many of these homes were torn down in the 20th century to make way for businesses and parking lots.

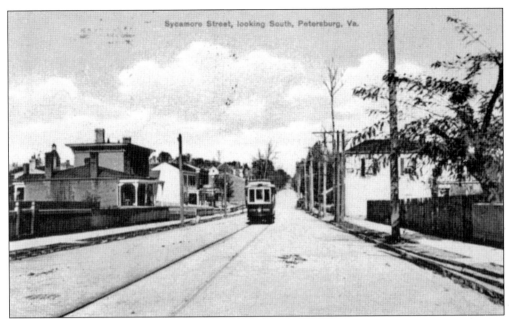

SYCAMORE STREET LOOKING SOUTH. A streetcar line was added out South Sycamore Street to the newly developing Walnut Hill neighborhood by the Virginia Passenger and Power Company after 1901. While the northern end of Sycamore Street remained commercial, residences were being built on South Sycamore Street as early as the second quarter of the 19th century. The neighborhood continued to grow through the last quarter of the 19th century.

BOULEVARD, WALNUT HILL. Several prominent Petersburg citizens built homes south of Petersburg in the area known as Walnut Hill in the first quarter of the 20th century. One of the largest was Ivy Gates, built by Harvey Seward, president of American Hardware Company. The land to the right of the street in the postcard was the northern boundary of Ivy Gates.

WESTOVER AVENUE, WALNUT HILL, PETERSBURG, VA.

WESTOVER AVENUE, WALNUT HILL. After the annexation of Walnut Hill into the city in 1921, prominent businessmen and professionals built homes for their families in this suburban neighborhood. The northern end of Westover Avenue developed rapidly between 1928 and 1936. Many of the homes were built of brick in the Colonial Revival style, an architectural style that was utilized in new suburban developments up and down the East Coast. The Colonial Revival style became a popular form of residential architecture from the 1876 centennial up until the 1930s. This genre was composed of combinations of various Colonial styles and reflected America's rapidly growing interest in the country's Colonial heritage and historic preservation.

WESTOVER AVE., WALNUT HILL, PETERSBURG, VA.

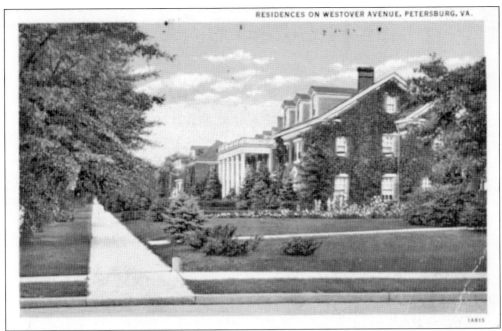

RESIDENCES ON WESTOVER AVENUE. Usually Colonial Revival houses were larger than their Colonial counterparts. Architectural elements common to these subgenres included symmetrical facades, side porches, cornices complete with decorative moldings, fanlights over entry doors, and gable roofs with dormers. Windows with double-hung sashes and many small panes were also a common feature.

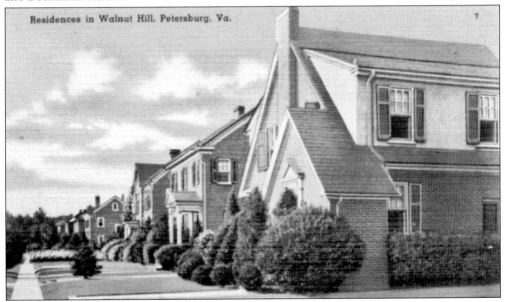

Residences in Walnut Hill, Petersburg, Va.

WALNUT HILL RESIDENCES. In addition to the homes on Westover Avenue, more modest-sized residences were also being built throughout the neighborhood in the second quarter of the 20th century. While some homes were built in the Colonial Revival style on a smaller scale, other architectural styles were utilized as well. Craftsman bungalows, Prairie-style, and English Tudor–style homes are represented in the neighborhood.

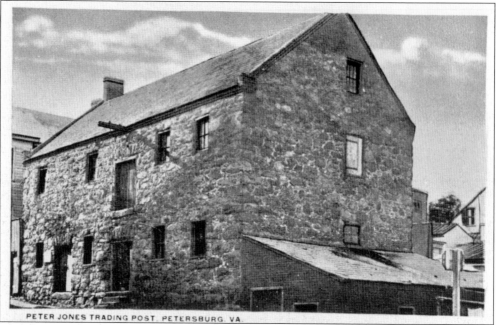

PETER JONES TRADING POST. PETERSBURG. VA.

PETER JONES TRADING POST. One of the earliest buildings in Petersburg that survived into the 20th century was this stone structure known by locals as the Peter Jones Trading Station. Located on land that was the site of 17th- and 18th-century trading operations, this Colonial-era building was used for a variety of purposes, including as a prison during the Civil War.

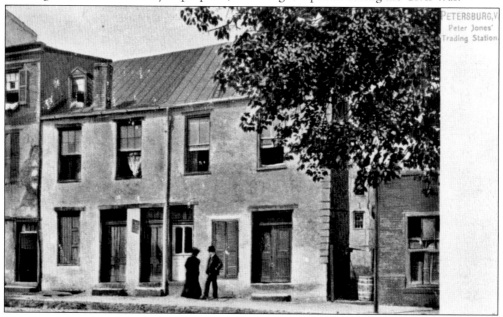

PETERSBURG, V
Peter Jones'
Trading Station

GOWANS' ROW. These buildings were built in 1808 near the intersection of Market and Grove Streets. Although the buildings are located in close proximity to the site of Peter Jones Trading Station, the postcard incorrectly identifies them as the Trading Station. The 300-year anniversary of Jamestown in 1907 led to an increased interest in documenting sites related to America's early history. However, little evidence of these original structures remains today.

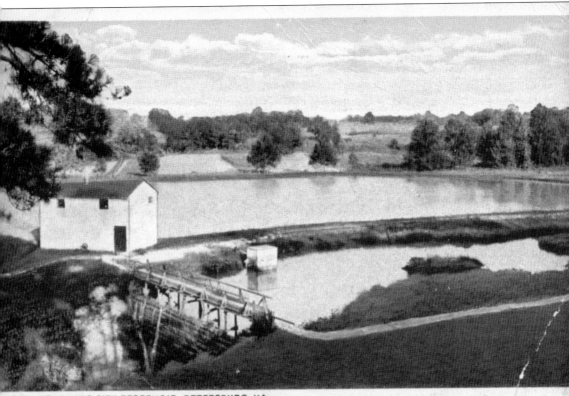

SCENE SHOWING CITY RESERVOIR, PETERSBURG, VA.

CITY RESERVOIR. In 1800, an act was authorized to establish a network of subterranean pipes from several springs in and around Petersburg to furnish water to the city's inhabitants. The system was upgraded in 1822, when the Petersburg Aqueduct Company was incorporated. Their mission was to obtain water from the canal, river, and springs located within one mile of the city and build pipes to convey the water through city streets. Bollingbrook, Old, and North Sycamore Streets were served by the company. In 1856, Petersburg's municipal water system was established. By 1917, the city's primary water supply was taken from the power canal of the Virginia Railway and Power Company. Under pressure, the main through which the water was brought into the city had a daily capacity of approximately five million gallons. The city reservoir shown in this postcard provided an auxiliary water source. The reservoir, located in the vicinity of Webster and Mercury Streets, was formed by damming a narrow ravine that contained a spring-fed stream. The reservoir had a storage capacity of 90 million gallons. (Postcard courtesy of Chris Calkins.)

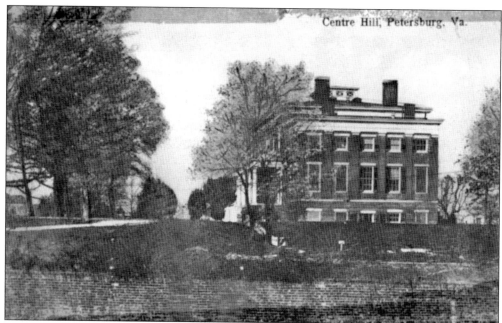

CENTRE HILL. Charles Hall Davis, his wife, Sallie, and son, Charles Hall Davis Jr., lived in this historic residence between 1900 and 1936. This view shows a sunken garden that was located to the east of the house. The Davis family remodeled the house, adding a grand Colonial Revival–style staircase, electricity, and indoor plumbing.

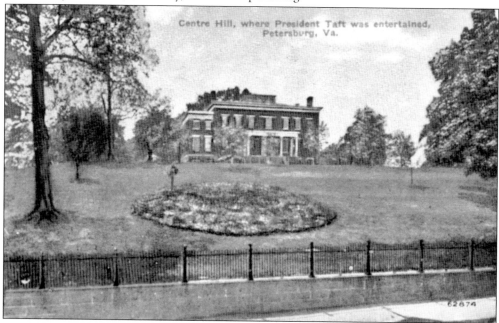

Centre Hill, where President Taft was entertained, Petersburg, Va.

CENTRE HILL LAWN, WHERE PRESIDENT TAFT WAS ENTERTAINED. On May 19, 1909, a luncheon and reception were held at Centre Hill for President Taft, who was visiting Petersburg for a Civil War monument dedication. The carpet garden seen in this postcard marked the spot where President Taft stood to greet the crowds of Petersburg citizens who lined up to catch a glimpse of him.

CENTER HILL, PETERSBURG, VA.

CENTRE HILL NEIGHBORHOOD. In 1910, the land around Centre Hill was purchased from Charles Hall Davis by a real-estate corporation, which divided the property into residential lots. During the 1920s and 1930s, houses were constructed around the circular drive in front of the house. The neighborhood became home to several of Petersburg's downtown merchants and their families.

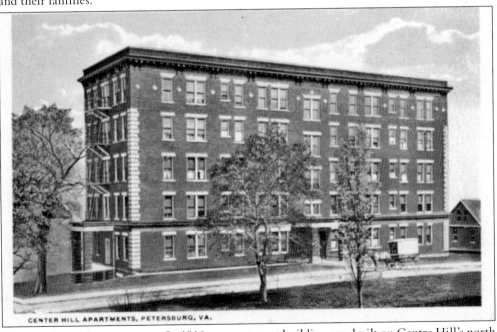

CENTER HILL APARTMENTS, PETERSBURG, VA.

CENTRE HILL APARTMENTS. In 1916, an apartment building was built on Centre Hill's north lawn on the site where President Taft had greeted the citizens of Petersburg. The five-story building was originally home to mostly retail and sales professionals who worked in downtown Petersburg. By 1993, the building had fallen into disrepair and was demolished.

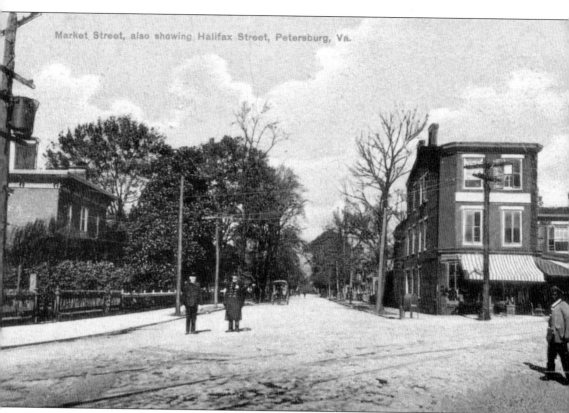

INTERSECTION OF MARKET AND HALIFAX STREETS. A mix of businesses, residences, and churches characterized this neighborhood. First Baptist Church, home to the earliest organized African American church in the United States, is located several blocks from this intersection. The church's congregation was organized in 1774. Their current building, located at 236 Harrison Street, was built in 1870 and remodeled in 1885. Other African American churches in the immediate vicinity include St. Stephen's Episcopal Church, which was organized in 1868, and Gillfield Baptist Church, home to the second oldest African American congregation in Petersburg. Organized in 1786, the church built the first of four church buildings on its lot on Perry Street in 1818. By the second decade of the 20th century, businesses on Halifax Street adjacent to this intersection included a fish market, drug store, bakery, and shaving parlor. In the early 20th century, many homes still lined Market Street. The Thomas Wallace House, built prior to the Civil War, can be seen in the left foreground. (Postcard courtesy of Chris Calkins.)

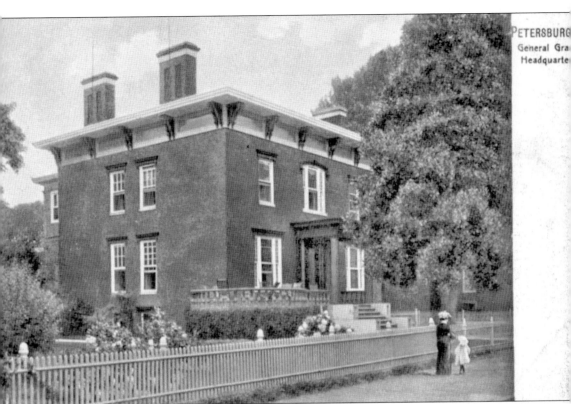

THOMAS WALLACE HOUSE. Thomas Wallace was the president of the Petersburg branch of the Exchange Bank of Virginia. His house received minor damage during the siege, when two shells struck his roof. On the morning of April 3, 1865, after Petersburg officially surrendered to federal troops, General Grant and his staff entered the city and occupied Wallace's residence. The night before, Grant had telegraphed President Lincoln, who was staying at City Point, and requested a meeting in Petersburg the next morning. Lincoln and his party rode part of the way by train and the remainder on horseback to reach the Wallace house. Grant and Lincoln sat in chairs on the front porch of the house and discussed military and political affairs for approximately 90 minutes. After the meeting, General Grant boarded a train to rejoin his troops. After a stroll through the city, Lincoln returned to City Point.

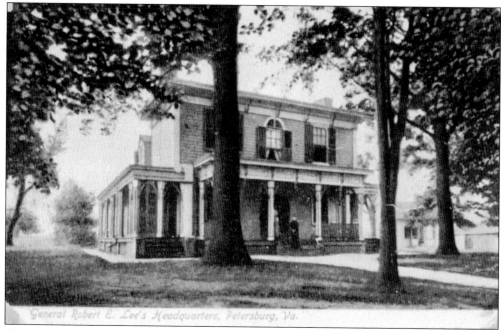

GEN. ROBERT E. LEE'S HEADQUARTERS. This house, which was extensively remodeled after the Civil War, served as General Lee's headquarters for most of November 1864. William Beasley bought the property in 1844 and built this residence in 1857. A small building on the property was used by Lee as his office during his stay. On November 23, Lee's headquarters were moved to the western edge of Petersburg—the Beasley House had been rented by newlyweds who were eager to move into the residence.

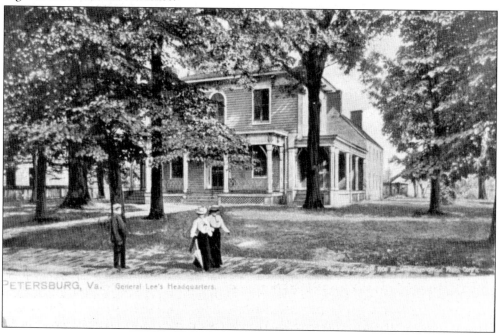

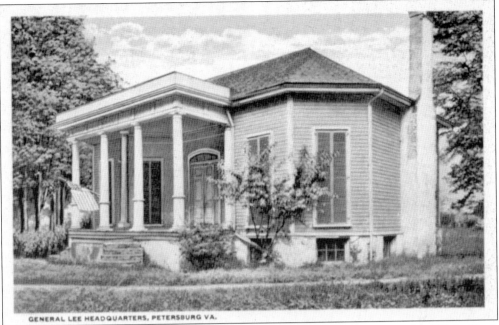

GENERAL LEE HEADQUARTERS, PETERSBURG VA.

VIOLET BANK. Gen. Robert E. Lee's headquarters were located on the grounds of Violet Bank from June to November 1864. Originally the property extended south to the Appomattox River and east to what is now Interstate 95. Gradually the land that made up the original grounds was sold off and developed. Today the house known as Violet Bank is located in Colonial Heights.

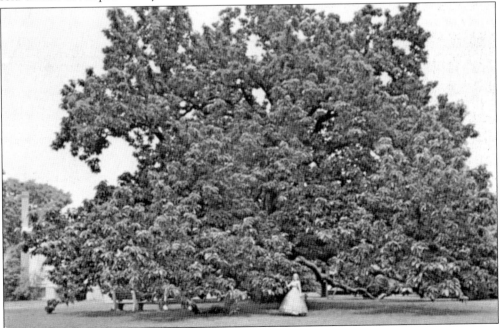

CUCUMBER TREE. Located on the grounds of Violet Bank, the scientific name of this tree is *Magnolia acuminata*, the most widespread and hardiest of the eight native magnolia species in the United States. This species is characterized by its impressive size. Legend says that General Lee pitched his tent in close proximity to this tree.

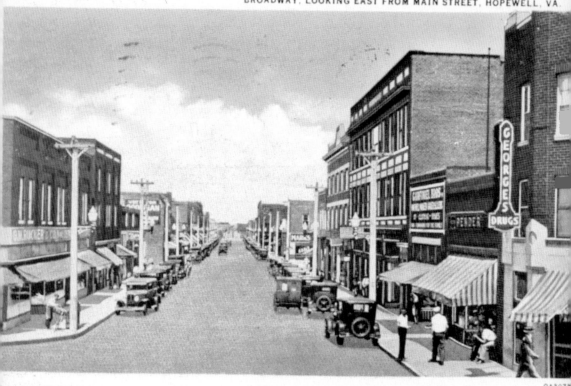

OA307B

HOPEWELL, VIRGINIA. City Point, the oldest section of Hopewell, was founded in 1613. Located at the confluence of the Appomattox and James Rivers, the port at City Point became a shipping link between Richmond, Norfolk, and points beyond. In 1838, a railroad was built connecting City Point to Petersburg. During the Civil War, the federal army established a supply center at City Point to bring in goods for troops occupying the siege lines around Petersburg. During the Siege of Petersburg, General Grant established his headquarters at City Point. After the Civil War, the area around the City Point wharf returned to a quiet village, until the E. I. Dupont de Nemours Company purchased a tract of land and built a factory. In 1914, the city of Hopewell was established on land laid out by the Dupont Company and private business owners. While the Dupont factory closed in 1918, other industries were soon established. By 1930, Hopewell's population had reached over 10,000. The downtown became a bustling center of activity and contained pharmacies, department stores, movie theaters, and restaurants.

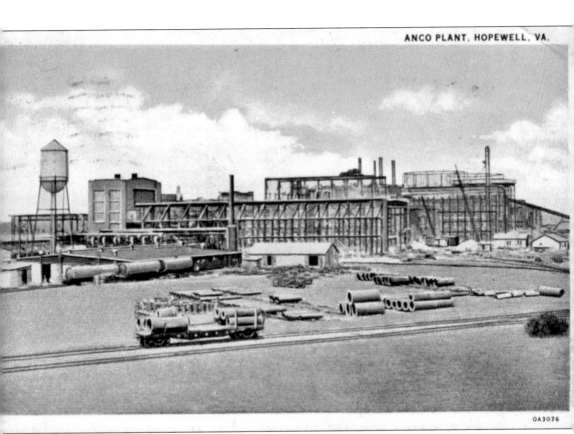

OA3076

ANCO PLANT, HOPEWELL. In 1912, the first factory was built by the E. I. Dupont de Nemours Company in Hopewell. By the end of 1914, the factory employed 20,000 workers. The factory produced dynamite until World War I, when production shifted to guncotton, an explosive ingredient of gunpowder. When the Dupont factory closed in 1918, the town's population rapidly shrank to 1,300. However, new industries quickly sprung up in the 1920s, initially occupying Dupont's factory and surrounding property. By 1930, Hopewell's population was over 10,000. Industrial plants manufactured a variety of products, including artificial silk, cellulose, tools, and chemical products.

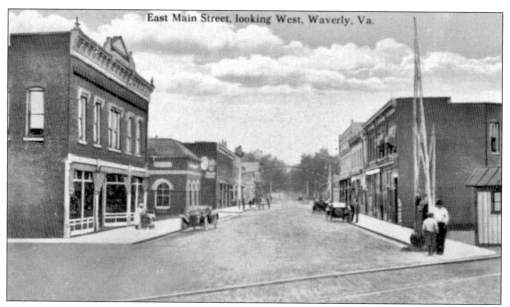

East Main Street, looking West, Waverly, Va.

WAVERLY, VIRGINIA. The town of Waverly is located approximately 25 miles southeast of Petersburg. The first commercial peanut crop in the United States was grown near Waverly around 1842. By 1909, the production of peanuts in the 12 counties included in Petersburg's trade territory exceeded two million bushels. The peanut factories in Petersburg produced 18 percent of the value of peanuts graded, roasted, cleaned, and shelled in the United States.

Tobacco Sale, an ever interesting Scene S-522

TOBACCO SALES. In 1917, five to seven million pounds of leaf tobacco were sold in local warehouses. Approximately 50 million pounds of tobacco were handled by Petersburg companies that same year. Companies manufactured cigarettes and smoking tobacco exclusively for export trade and cigars, plug tobacco, and twist tobacco. Ten tobacco companies, including three large sales warehouses, were located in Petersburg, and in 1917, they employed more than 3,000 individuals.

VIRGINIA STATE CAPITOL, RICHMOND, VIRGINIA

STATE CAPITOL BUILDING, RICHMOND. Located 23 miles to the north of Petersburg, the city of Richmond was founded in 1737, although settlers had lived in the area since the 17th century. Patrick Henry gave his famous "Give me liberty or give me death" speech to the Second Virginia National Convention in Richmond's St. John's Church in 1775. In 1779, the Virginia legislature voted to move the state capital from Williamsburg to Richmond. The capitol building was designed by Thomas Jefferson and completed in 1788. Jefferson designed the building after an ancient Roman temple in France. During the Civil War, when Richmond became the capital of the Confederacy, the Confederate legislature occupied the capitol building. The two wings on either side of the central building were constructed between 1904 and 1906 for the House of Delegates and Senate chambers. Since the 19th century, Petersburg residents have had several direct transportation routes to the capital, first by steamboat and train and later by an electric railway and highways.

SUSIE R. C. BYRD. In the early 20th century, photographic portraits of individuals were also printed as postcards. This postcard is of Susie Byrd, who resided at 450 Harrison Street in Petersburg's Ravenscroft neighborhood. A teacher by profession, in 1937, Byrd was assigned as a federal writer for the Petersburg district of the Negro Federal Writers' Project of Virginia, a program funded by the government to provide work relief employment during the Depression. Byrd's duty was to collect the history of Petersburg's African American community, chiefly by interviewing ex-slaves. Byrd interviewed approximately 50 ex-slaves, many who resided in her neighborhood. Rev. John Brown and his wife, Liza, were instrumental in assisting Byrd with locating interviewees. Meetings would be held in homes once a week; the ex-slaves would gather to sing songs, tell stories they remembered about slavery, and share refreshments. Excerpts from these interviews can be found in several publications. Byrd died in 1960.

JOSEPH COTTEN. This is a promotional postcard for the 1946 movie *Duel in the Sun*, starring Petersburg native Joseph Cotten. Cotten was born in Petersburg on May 15, 1905. He debuted on Broadway in 1930 and became friends with actor and director Orson Welles when they met while working for the Federal Theatre Project, a branch of the Depression-era, federally funded Works Progress Administration, which provided employment for actors, directors, and scene designers. In 1941, Cotten costarred with Welles in the movie *Citizen Kane*. Cotten would star in over 40 movies, including *Shadow of a Doubt*, *Gaslight*, *The Third Man*, and *Peking Express*, in a career that spanned nearly 40 years. In the early 1960s, Cotten hosted and narrated the television series *Hollywood and the Stars*. He retired from acting in the 1980s after suffering a stroke and died in 1994 at his home in California. Cotten is buried in Blandford Cemetery in Petersburg.

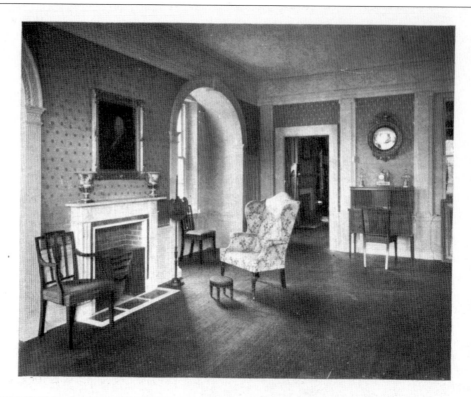

AMERICAN ROOMS, PETERSBURG, THE METROPOLITAN MUSEUM OF ART. In 1924, woodwork from the Robert Moore house in Petersburg was reconstructed in the American Wing of the Metropolitan Museum of Art in New York City. After the Revolutionary War, Moore became a prosperous tobacco merchant in Petersburg. His house was located at the corner of Bank and Second Streets. In 1916, the Metropolitan Museum purchased the interior architectural elements of the front parlor as the house was undergoing demolition. This postcard view of the reconstructed parlor dates to 1924; one year later, the mantel and over-mantel from the parlor's fireplace were donated to the museum and installed in the parlor's interior. The room's moldings are examples of the Adamesque style, the dominant architectural style in the new nation from the late 18th century to 1820. However, the original craftsmen took some liberties in designing the room, including the window arches intruding on the cornice and the pilasters flanking the windows. The period furnishings in the museum installation were not original to the house. (Postcard courtesy of Chris Calkins.)

BIBLIOGRAPHY

Boyd, Robin. *Gone But Not Forgotten: Petersburg Virginia's Lost Landmarks.* Richmond: Master's thesis, unpublished, 1981.

Calkins, Chris. *Auto Tour of Civil War Petersburg 1861–1865.* Petersburg: City of Petersburg, 2003.

Green, Bryan Clark, Calder Loth, and William M. S. Rasmussen, eds. *Lost Virginia: Vanished Architecture of the Old Dominion.* Charlottesville, VA: Howell Press, 2001.

Henderson, William. *From Trolley to Bus: the Development of Public Transportation in Petersburg, Virginia.* unpublished paper, 1976.

———. *Petersburg in the Civil War: War at the Door.* Lynchburg, VA: H. E. Howard, Inc., 1998.

Heslop, Page. *Pastors, Pulpits and Petersburg: A Profile of Second Baptist Church and the Cockade City 1854–1994.* Petersburg: Second Baptist Church, 1994.

Hodges, LeRoy. *Petersburg, Virginia Economic and Municipal.* Petersburg: Petersburg Chamber of Commerce, 1917.

Nichols, C. M., ed. *International Magazine of Industry and the Daily Progress Descriptive and Illustrating Petersburg, Virginia.* Petersburg: Virginia Printing and Manufacturing Company, 1912.

O'Gorman, Tim and Dr. Steve Anders. *Fort Lee.* Charleston, SC: Arcadia Publishing, 2003.

Perdue, Charles L., Thomas E. Barden, and Robert K. Phillips, eds. *Weevils in the Wheat: Interviews with Virginia Ex-Slaves.* Charlottesville, VA: University of Virginia Press, 1976.

Peters, John. *Blandford Cemetery: Death and Life in Petersburg.* Petersburg: Dietz Press, 2005.

Petersburg VA City Directories. Richmond: Hill Directory Company, 1903–1980.

Scott, James G. and Edward A. Wyatt IV. *Petersburg's Story: A History.* Petersburg: Titmus Optical Company, 1960.

Trout, William E. III, Ph.D. *Appomattox River Seay Stories.* Petersburg: Historic Petersburg Foundation and Virginia Canals and Navigations Society, 1992.

Wallace, Lee A. Jr. and Martin R. Conway. *A History of the Petersburg National Battlefield.* Washington, D.C.: Department of the Interior, 1983.

ACROSS AMERICA, PEOPLE ARE DISCOVERING SOMETHING WONDERFUL. *THEIR HERITAGE.*

Arcadia Publishing is the leading local history publisher in the United States. With more than 3,000 titles in print and hundreds of new titles released every year, Arcadia has extensive specialized experience chronicling the history of communities and celebrating America's hidden stories, bringing to life the people, places, and events from the past. To discover the history of other communities across the nation, please visit:

www.arcadiapublishing.com

Customized search tools allow you to find regional history books about the town where you grew up, the cities where your friends and family live, the town where your parents met, or even that retirement spot you've been dreaming about.